W9-CSP-863

EUGÈNE ATGET

EUGÈNE ATGET
Paris

With an introduction by Wilfried Wiegand

te Neues Publishing Company

New York

Contents

Introduction

7

Plates

25

Chronology

105

Select Bibliography

108

Introduction

From 1900 to 1914," Stefan Zweig remembered, "I never saw the name Paul Valéry mentioned as that of a poet, either in *Figaro* or in *Matin*; Marcel Proust was considered the dandy of the salons, Romain Rolland a knowledgeable musicologist. They were almost fifty years old before the first faint ray of fame reached their names, and their grandiose work had been achieved in the dark, within the most curious, the wittiest city in the world." In this darkness there also lived the greatest European photographer of the time, and he had to wait until he was almost seventy before the first rays of fame lit up his name: Eugène Atget, born in 1857 in Libourne, died in 1927 in Paris.

In the course of Atget's career he did not remain completely unknown. The Parisian libraries and museums had for many years bought his photos of the old city that was doomed to disappear. And since he always understood his photographs as "documents pour artistes" – as raw material, as models for painters, sculptors, stage designers, and craftsmen – it was inevitable that some artists knew him and perhaps even bought pictures from him. But no one thought the taciturn, seemingly embittered man was a great artist. Atget was an outsider, whose obsession with photographing *Vieux Paris* as completely as possible was probably laughed at just as much as was his old-fashioned equipment with plate camera, tripod, and black cloth. And as one eye-witness reported, photos were often bought from him "primarily to do him a favor because he aroused our pity a little."

From 1899 until his death – for twenty-eight years – Atget lived on

rue Campagne-Première, house number 17bis. The little street on Montparnasse, barely 350 yards long, has played a role in the history of literature more than once – Verlaine met here with Rimbaud, Stefan Zweig visited Rilke, Aragon found Elsa Triolet. But it became famous primarily as the abode of painters, sculptors, and models. Since Montmarte had become a pleasure district, many artists moved to the other end of the city, to Montparnasse, and now, as more and more wealthy foreigners were arriving, renting studios became a business. In the beginning, there arose in courtyards and cul-de-sacs numerous *cités d'artistes* with their many little studios; later on more luxurious buildings were constructed with high-ceilinged studios and the large glass façades we still notice today. In rue Campagne-Première there are both: a *cité d'artistes* with over a hundred studios and since 1911 a prestigious building with studios on its four high stories. In this street famous artists and models have lived next to the unknown; even before the turn of the century it was a meeting point par excellence for artists. At the beginning of the 1930s the Parisian chronicler Léon-Paul Fargue remembered the pleasure-hungry time before the Great Depression, when "all night long the taxis drove up and down rue Delambre, rue Vavin, and rue Campagne-Première" full of fashionable night lifers from all over the world. And Eugène Atget lived in this street for nearly thirty years – no doubt because artists were important customers for him, but that does not exclude another reason for residing in the heart of the bohemian world: a feeling that he belonged because he was an artist himself.

On the south side of rue Campagne-Première little has changed. The large studio building in which Man Ray lived after 1922 is still inhabited by artists, as is the *cité d'artistes*. The little hotel that Aragon immortalized in a poem is still there, and in the middle of the street there is a narrow apartment building, number 17bis, similar to those found on Haussmann's boulevards. On the façade a sign reads:

Eugène Atget
Père de la photographie moderne
a vécu dans cette maison
de 1898 à 1927

(Eugène Atget, the father of modern photography, lived in this house from 1898 to 1927.)

Overlooking the mistake in the date (1899 is correct), looking upwards, we see the window on the fifth floor where Atget, following a procedure used in the nineteenth century, printed his photos. Using a wooden frame, he lay the plate on light-sensitive paper and exposed it to the sun until the print became dark enough. Once, when Man Ray offered to print the images on modern photo paper, Atget refused because he could not imagine that such prints would last. Atget's apartment lay under the attic and had three rooms, one of which served as laboratory, archive, and kitchen. We know what the interior looked like from Atget's own photos. There was little furniture, but the walls of the living room were amply and neatly covered with books, archive portfolios, and reproductions of art works. The impression is of a modest but proper, petit-bourgeois household in which love of art and literature played an important role. Atget did not live alone but with a woman who had been quite successful in the theater world and received a small pension from her guild. She was ten years older than he and had an illegitimate child. This woman had a stabilizing influence on Atget's life, and her death in 1926 left him disheartened and embittered. The three portrait photos that Berenice Abbott took shortly before Atget's death in 1927 show him in this state: thin and bent with age, he appears almost pitiful in his now oversized coat.

At the age of twenty-one Atget came to Paris to become an artist. He was orphaned early on and spent his youth, without siblings, in modest

circumstances with his grandparents in Bordeaux. He had a normal education; perhaps he even learned the ancient languages and may have gone to sea as a young man. In Paris he settled down in one of the poorest areas, near the slaughterhouse of La Villette, and applied for entrance to the state acting academy. The stocky young man with the obvious accent was admitted after the second try, became a pupil of the famous Edmond Got – he whom Proust's narrator in *À la recherche du temps perdu* called the greatest actor of the Comédie-Française – but left soon thereafter. In addition to his studies, he had to serve in the military and his performance at the academy suffered.

Atget's love for the theater must have been passionate. After finally being discharged, he decided to join a troupe of actors that performed primarily in the suburbs of Paris and in the country. His alleged appearances in Parisian theaters have not been documented; thus they could only have been in small roles or in the second cast. When he was thirty he had to give up his career, ostensibly because of an illness affecting the vocal cords – but perhaps this reason was meant to conceal an inglorious end to his theatrical career.

During his acting years Atget also lived in a street where bohemians gathered: on rue des Beaux-Arts, next to the art academy. He was in contact with artists and art students and after giving up acting – for whatever reason – he began to move in painters' circles and try his hand at painting. His small-format landscapes and studies of trees do not reveal much talent, however, and with no signs of success he soon gave up painting. Nevertheless, he always valued his oil sketches and implied in conversations later on in life that he still painted. This was probably not true but it reveals how important it was for him to be considered an artist. It was only after his unsuccessful attempts at painting that Atget started to photograph. Should we see this as resignation, as the end of his dream of becoming an artist? Perhaps he himself saw it this way for a time or indeed for his whole life. His life's work – that most ambitious

encyclopaedia of Paris since Balzac's *La Comédie humaine*, that archive of dying life styles – clearly shows, however, that he was an artistic genius, regardless of how he saw himself. Atget left some eight thousand photos; almost one and a half thousand of them have been reproduced in books published after his death. No other photographer can compete with these numbers. For us Atget has become the most familiar photographer of the past.

Throughout his life Atget sold his photographs as "documents pour artistes." He had an address book in which he noted the names of his buyers and potential customers, their addresses, the nearest métro stations, the best times to visit them, and other details. We know that some artists actually used his photos as models. In a history painting, for example, there is an oddly shaped windmill which is an exact copy of an Atget photo. No doubt Maurice Utrillo was one of his customers, even if as yet no reference to Atget has been found in his oeuvre. Although a contemporary of Atget has maintained that Braque was also a customer, this seems less likely. We would like to know more on this matter, but Atget's address book, which was not preserved in its entirety, does not offer any more information.

Even when he was very busy with the selection and preparation of entire series for museums and libraries, Atget continued to sell individual photos to artists. Beginning in 1925, for example, Man Ray bought approximately forty prints, and in the following years, until shortly before Atget's death, Berenice Abbott used her modest financial means to purchase photos from him. It had always been important for him that each and every photo was able to stand on its own. All his pictures had to be sellable; they all had to have a special quality that could inspire artists – and in order to achieve this he invested all his artistic skill in every single photo.

In his photography Atget used dry plates, which in contrast to the

"wet" procedure did not require that the photo be made light-sensitive on site. The dry plate gained acceptance in the 1880s and was the only technical advance that Atget profited from. His wooden camera, even with collapsed bellows, would have been as large as a modern attaché case. He also had to transport a massive tripod and cassettes with glass plates (7 x 9½ inches in size). All in all his equipment must have weighed about forty-five pounds. Focusing was done under the black cloth on the screen with the image reversed and upside-down. Thus the composition required more care and sense of proportion than is required today with a viewfinder. Furthermore, it is now standard procedure to snap the same motif many times – an impossible undertaking then because the glass plates were too costly. Even so there were smaller cameras with better depth of focus and shorter exposure times when Atget began to photograph. And ever since the 1900 World Exhibition it had become commonplace to see a tourist carrying a camera in Paris. From year to year Atget must have seemed more idiosyncratic and old-fashioned to his contemporaries.

Since the beginning of photography Paris has been a favorite subject of Parisian photographers. If we overlook portrait photos, which were the main source of income for photographers, then there is nothing that was photographed as much in Paris as Paris itself. The reason for this was not only the initially long exposure times, which required stationary subjects; more importantly it was because architectural photos could be sold – much more easily than landscape photos, for example. Photographed landscapes were not in color, which made them inferior to painting; in contrast photography was at an advantage with architectural motifs – no painter or graphic artist could possibly achieve the exactness of a photo. Photos of streets and squares with interesting buildings guaranteed commercial success: architects bought them as models, tourists as souvenirs, authorities for their archives.

In the 1850s and 1860s Paris experienced a unique flowering of architectural photography. At a time when Paris was so proud of its past, the old city was being gutted at a pace that would not normally have been tolerated in peacetime. The demolition work, which the prefect Haussmann masterminded to create room for the new Louvre and for a network of wide boulevards, destroyed the medieval city. Both the destruction and the reconstruction were documented by the best Parisian architectural photographers, primarily on behalf of local authorities. Baldus, Le Gray, Marville, and the Bisson brothers were commissioned to photograph the Louvre, the most ambitious project of Emperor Napoleon III. In 1865 Marville was entrusted with a special undertaking: in exactly 425 photos he was to record the appearance of the streets soon to be demolished in the historical part of the city. He worked for four years on this project, and later he was given the official task of photographing the new buildings on the boulevards, including their lanterns and public conveniences.

Charles Marville, who can best be regarded as Atget's predecessor, portrayed *Vieux Paris* without a hint of nostalgia. Working for the authorities who planned the demolition and rebuilding, he made sure that the buildings and cobblestones in the old quarters were covered with moisture so as to suggest unhygienic conditions. Conversely, the new buildings and streets were depicted in a manner that demonstrated social progress. Atget's camera eye, on the other hand, was guided by a love of everything handed down from the past. For this reason he was unable to see anything of interest in recent buildings, not even in Garnier's magnificent Opéra or the iron construction of the Eiffel Tower, which he ignored along with other impressive buildings erected for world exhibitions in Paris.

Marville's photos, which at first glance may seem similar to Atget's, are technically superior. Marville was able to manage a much larger format and to calculate the light better, thereby avoiding over-exposure

and back-lighting. Marville's work was done flawlessly and with scientific precision. He was a specialist who carried out his commission professionally, carefully preventing any personal interest from entering his work. In comparison to Atget, Marville seems cold and severe. Although Atget's streets are frequently empty of people, his interest in the traces of human activity is conspicuous. He loves the artistic endeavors of past generations, and his houses are like props in a theater with someone just about to step onto the stage. The shop windows with their mannequins or with their stock lined up in rows could be taken from a puppet theater. Marville imagines that the people are gone; Atget imagines their presence. No one wants to live in Marville's narrow streets of the old city. In Atget's houses the fantasy of the viewer makes itself at home. Atget is curious, he clearly has preferences, and, as if in a film, he can turn a bagatelle into something major in a close-up. What can be said about Atget would never be said about Marville, Baldus, and the Bissons. His photos are fragments, extracts from a personal account.

Atget could have seen photos taken by Marville at the 1878 World Exhibition but we have no proof. Marville worked as a photographer in Paris until 1878 and Atget did not begin until 1897, but the suggestion that because of a gap of twenty years between himself and classical Parisian architectural photography Atget had to start from the beginning is wrong. The tradition was carried on at a most sophisticated level. Between 1870 and 1910 several photographers were commissioned by the office for the preservation of historic monuments to take approximately twenty thousand photos, for which glass negatives of an imposing size (11¾ x 15¾ inches) were used. Amongst the subjects from all over France are numerous Parisian buildings, most of which were protected by preservation laws or were planned to be put under protection. In contrast to Atget's images, which were the result of a curious eye bent on discoveries, these photos were motivated by art-historical interests, especially stylistic characteristics. Nevertheless, the

motifs and the details are astonishingly similar. That Atget could have seen these technically compelling photos is not improbable. Perhaps they were shown to him as examples of perfect documentary photography – either as model or reproach – by one of the institutes he worked for or wanted to work for.

Atget's work reflects to a large degree his biography, as far as that is possible in architectural photography. There are the early works that reveal his struggle with the technical medium, his inability to focus thematically, and his more conventional artistic approach. Then there is the decade-long mature period with his photos of Paris, a Balzacian will to systematize, and stage-like details. Finally there is his late oeuvre which expresses his social consciousness with the commitment of a reporter. In these photos he depicts the absurdity of the modern world in shop windows that look like miniature stages and in the grotesque spectacle of amusement parks. But there are also the quiet, empty parks that reflect perhaps the loneliness he felt as an old man.

It was around 1897 that Atget began to photograph Paris in a systematic manner. He sold his photos to individual customers or to companies and in larger numbers to Parisian libraries and museums. The Victoria & Albert Museum in London acquired just under four hundred prints. He also received commissions. The series of eighty photos entitled "Petits Métiers de Paris" – street-vending in Paris – was probably commissioned by a publisher who sold printed postcards. For a collector of erotica he shot photos of prostitutes, which, however, did not satisfy the wishes of the customer. Other series, especially those with details of various crafts and trades, were probably also commissioned or undertaken with a view to a particular commercial buyer. Around 1907 he was asked to prepare an extensive documentation of the historical city by the Bibliothèque Historique de la Ville de Paris.

It would be inaccurate, however, to conclude that Atget was just a

contract photographer, without a concept, waiting for clients to approach him with their wishes. This may have been the case in his early years when, as we can see from his business card, he listed: "Reproductions of paintings, foregrounds for artists, landscapes, animals, flowers, architectural monuments." A good ten years later, when he began focusing on Paris, he had made the change from a vocational to a conceptual understanding of his work.

From 1910 onwards Atget laid out thematic albums, several of which he sold to Parisian institutes. These included "L'art dans le Vieux Paris" with its details of architectural craftsmanship; "Intérieurs Parisiens, Début du XXe siècle" with its photos of furnished apartments, including his own, whose tenants he referred to as "artistes dramatiques"; "La Voiture de Paris" with coaches, carriages, and horse-pulled streetcars, but no automobiles; "Enseignes et vieilles boutiques de Paris" with the attractively barred windows of Bistro façades; and "Zoniers," in which, in the "zone," the neglected outskirts of Paris, rag-and-bone men, junk dealers, and traveling salesmen were photographed without a touch of voyeurism, posing proudly before their possessions. The idea of these thematic albums – containing about sixty photos on average, each picture with a succinct and factual caption – can probably be traced to Atget himself, who would gladly have had someone commission this work because he wanted to publish in book form. In fact, he had already provided some of the albums with printed title pages, perhaps to get a bit closer to his goal. A book edition never was realized, however, probably because his captions, which were taken primarily from a Paris guidebook, were not substantial enough for his albums to compete with professionally made volumes on the city.

The plan to document the buildings of Paris – not with a view to a tourist's interest in sights or based on random choice but following a systematic approach – was probably suggested by the subject itself. The city of Paris, divided up like chapters into its twenty *arrondissements*,

had been made accessible with all its sights, street by street, by guide-books, and a flood of "sociological" articles in newspapers – in imitation of the physiologists of a past era – discussed in every season, again and again, the differences in the social classes, professions, and types of people. Paris was a city which was falling into manifold categories. It also had great literary personages such as Mercier, Balzac, and Zola who were interested in portraying the city in its sociological and psychological features. Some of these categories are reflected in Atget's work. Strangely, what did not interest him was the historical development of various art styles. He did not think of distinguishing between Gothic and Renaissance buildings; rather he merely separated the old from the modern. His love was for the old; the new he either ignored or depicted with some irony. What guided his eye and shaped his choices, in addition to his love of traditional beauty, were the interests of his business customers – craftsmen, architects, and interior decorators. For them he discovered a still usable beauty and by making it accessible to other artists he provided the material for artistic recycling. Having grown up in the era of historicism, he would not have found this work – the supply of artistic models – to be a burden. Rather he would have seen it as a laudable contribution to the enrichment of visual culture.

When he was criticized by the Bibliothèque Historique de la Ville de Paris for the inferior technical quality of some of his photos, Atget defended himself with the pride of an artist who knows his value and knows that it cannot be measured by the quality of a few individual works. He pointed out the immense number of Paris photos he had taken "more out of love for *Vieux Paris* than for profit's sake."

Atget spent more than two decades working on this subject matter, and he probably would have continued if the World War hadn't halted his collector's urge to complete the project. During the war, when he appeared on the street with his camera, he was sometimes suspected of

being a spy, which in his own beloved Paris was humiliating for him. When the war was over, he did not return to the city center; rather he chose the empty parks and palace gardens, where he was not reminded of the humiliation he suffered, as the surroundings for his new objects of interest. The war also threw another shadow on his work. The bombs dropped from German airplanes and airships on Paris terrified him and as a result he deposited his glass negatives in the cellar. During this time some of them were severely damaged by humidity. The barbarity of modern life, which had threatened to demolish his beloved *Vieux Paris*, now threatened to eliminate the memory of it. He finally drew the consequences and decided to offer a large portion of his archive to the State. On 12 November 1920 he wrote the director of the art department at the Ministry of Education a letter which contains the most moving description of his art that he ever gave:

> Sir,
>
> For more than twenty years, on my own initiative and with my own hands, I have made photographic images (18 x 24 cm [7 x 9½-inch] format) of all the old streets of *Vieux Paris*, artistic documents of beautiful secular architecture from the sixteenth to the nineteenth century. The old hôtels, historic or curious houses, beautiful façades, beautiful portals, beautiful woodwork, the door knockers, the old fountains, the artistically fashioned stairways (wood and wrought iron), and the interiors of Parisian churches (ensembles and artistic details); Notre-Dame, Saint Gervais et Protais, Saint-Séverin, Saint-Julien-le-Pauvre, Saint-Etienne du Mont, Saint-Roch, Saint-Nicolas-du-Chardonnet, etc., etc.
>
> This vast artistic and documentary collection is today complete. I can claim to possess all of *Vieux Paris*...

For years Atget would leave his apartment early every day when

the streets were empty, frequently traveling quite far to begin his photographic work. To the Parisians who passed him by or watched him while he was adjusting his camera and its black cloth, he must have seemed a bit odd, just like Paul Cézanne was to the inhabitants of Aix. Like Atget, Cézanne left, heavily laden with his equipment, early in the morning, day in day out, to reach his *sujet* while it was still cool. Cézanne, too, had to tolerate derision and ridicule; he was considered a failure and an outsider, but he, like Atget, was not to be dissuaded from carrying out his ambitious artistic plans. Cézanne, too, was a fanatic who worked ever so slowly, who reacted with surliness when a successful painter wanted to show him how one paints a tree "properly." Similarly, Atget refused Man Ray's offer to use a Rolleiflex. The gadget, Atget explained, was too fast for him. In order to explain what role the unconscious plays in artistic work, Cézanne used, as did Proust, the metaphor of photography. Proust compared the arousal of memories with the development of a photographic plate, which is already exposed but does not reveal the image until the moment it is developed. Cézanne compared himself to the photographic plates of his youth, which had to be sensitized before being used to produce the most objective possible image of nature, unaffected by the individual will.

The greatest literary figure and the greatest painter of their times – both used a photographic metaphor in their reflections on art. It is not known whether Atget made any similar comments, and it is perhaps wrong to expect them from him. For the poet and the painter, photography is something outside their métier that they used to help explain their own work. Accordingly Atget would have had to use another art form to help him clarify the enigma of photography. And he did that, although not in words, in his own art. Atget's metaphor is the theater; it is the phenomenon that something magical happens when people step on stage. Thus in some of his photos a waiter suddenly appears in a dark glass door and then disappears, not without leaving an

unavoidable blur owing to the long exposure times. Didn't Atget see these figures while he was taking the photo? Why didn't he avoid including them in his shots? Above all, why didn't he touch up the print and remove them? All the architectural photographers touched up their photos; even in Marville's photos with their antiseptically clean streets this is noticeable. Apparently Atget, however, did not touch up; he let the mistake be a part of his picture. In two cases he is even visible together with his camera, a fact that he certainly did not overlook. Compared with the stage, his camera is tiny; nevertheless it has the power to let people appear suddenly – as if by magic. Atget used this magic, thereby creating a theater role for the waiter and himself.

Once, the reflections in his photos of shop windows were also regarded as mistakes. In the meantime it is no longer necessary to defend the reflections in a window pane that turn reality into pure appearance. It is exactly these photos – and that with the waiter – that are among Atget's most famous pictures today. What once was taken for granted – that photos should be a flawless reproduction of reality – is now seen as only one of several possible ways of working in photography. Julia Margaret Cameron also did not photograph flawlessly, and we consider the photos of the young Jacques-Henri Lartigue with their contorted perspectives brilliant because they demand more from the camera than the conventional approach dares to. Photography takes on an individual character because of the supposed flaws, and just as we perceive Cézanne's personality in his unfinished paintings, so we are also able to sense the trace Atget left in his photos. Atget's camera in the reflection of the chimney, the waiter in the door, and the façade in the shop window are apparitions that are found in only parts of the photo. They are images within an image. We see, quite correctly, the entire photo as a reproduction of reality, but the little picture within the picture is the commentary. In it Atget created a little drama which he perhaps experienced whenever he watched the

image uncannily appear on his print, namely his astonishment over a magical art that lets reality dissolve into appearance and appearance become reality.

When Man Ray was asked about his relationship to Eugène Atget, he answered proudly: "I discovered him!" Everything seems to support this statement and that they met at the latest in 1925. Both lived, only a few houses away, on rue Campagne-Première. Man Ray bought photos from Atget and had four of them published in Breton's magazine *La Révolution surréaliste*. Among them was the now famous photo showing a group of people with sun glasses looking up at a solar eclipse. The picture is on the title page of issue no. 7, which appeared on 15 June 1926, and carries the blasphemous sounding caption "Les dernières conversions." None of Atget photos had his name on it. This, according to Man Ray, was Atget's wish: "Don't put my name on them. These are simply documents I make." This was true if the quality of pictorial art photography was his standard, but Atget may have wanted to play down the quality of his photos so as to avoid being connected with the young Surrealists. Everyone knew that the Surrealists provoked State authority whenever they could and the State was one of Atget's best customers. Despite his political beliefs – he was a Dreyfus supporter and read Socialist journals – anxiety about his livelihood might have made him especially cautious.

In 1925 Man Ray showed his young American assistant Berenice Abbott some of Atget's photos. She was so excited by his work that she visited him several times, bought some of his photos, and told friends about him. After she left Man Ray, she opened her own portrait studio in 1926 and the following year asked Atget to visit her so that she could photograph him. Atget came: "To my surprise he arrived in a handsome overcoat. I had always seen him in his patched work clothes. . . . Later, when I took his portraits to his home to show them to him, I missed the

little sign 'Documents pour Artistes' on his door, went up a flight, then descended to the concierge, and inquired for Monsieur Atget. The concierge told me he had died. I was deeply shocked." The apartment had already been cleaned out but Berenice Abbott found an old friend of Atget's who was handling his estate. After involved negotiations, she was able to buy a selection of his photos. Some of these she lent to exhibitions and issued in the form of albums, before selling them all to the Museum of Modern Art, New York, in 1968. She was an untiring promoter of his work, and it was above all the photo album she published in 1930 with photos from her collection that made Atget into an internationally famous artist.

This book, which appeared in the same year in a French, German, and American edition, was seen by both Edward Weston and Walter Benjamin. The latter read in Camille Recht's preface to the German edition that one photo was reminiscent of a police photo taken at the scene of a crime. In 1931 Benjamin dramatized this comparison in words which have become famous: "Not for nothing were pictures of Atget compared with those of the scene of a crime. But is not every spot in our cities the scene of a crime? every passerby a perpetrator? Does not the photographer – descendant of augurers and haruspices – uncover guilt in his pictures?"

Benjamin's view was not new. In 1926 Aragon's *Le Paysan de Paris* had already described the language of the Parisian streets and read the promise of mysteries and crimes from its shop windows and signs. Two years later Breton's *Nadja* appeared, illustrated with photos of commonplace Parisian façades, which took on a mysterious quality only in relationship to the text. Now writers and critics began to pay tribute to Atget, even though in the beginning his name was frequently misspelled. Atget was praised as the photographer who discovered modern beauty in the everyday and commonplace. Young photographers were influenced by him – in addition to Berenice Abbott, above

all Walker Evans, who saw his photos in Paris. When they returned to America, both Abbott and Evans saw their home country with Atget's eyes.

Not everyone who discovered Atget thought he was a great artist. It was especially the perfectionists of photographic techniques, such as Man Ray and Edward Weston, who had problems accepting Atget's not infrequent technical negligence. That photography can be brilliant beyond the realm of flawless realism was then unimaginable. Julia Margaret Cameron was being rediscovered only gradually, and Jacques-Henri Lartigue did not have his first photo exhibition until 1963. It was not without an undertone of disparagement for Atget that Man Ray referred to the photos he chose as having a "Dada or Surrealist quality about them" whereas the others – "He had thousands of them: He'd photographed so much in his lifetime" – were just for mass consumption. Man Ray refused "to make any mystery out of Atget" because he was "a very simple man, almost naive, like a Sunday painter, you might say, but he worked every day."

None of the people who, around 1930, first discovered Atget were reminded of the great architectural photography of the past. It had been forgotten and Charles Marville was unknown. Paris photography was thought to include the photos made for decades for tourists and sold en masse in souvenir albums of every size and on postcards. They showed the famous monuments and the most best-known sights of Paris, if possible with a crowd of people, so as convey the bustle of the streets. Atget's photos with their classic composition, their quiet emptiness, and their conspicuous avoidance of the main sights had a completely different effect, and Atget's discoverers declared him their con-temporary because he did not appear to fit in his own era. That was surely an exaggeration, but after having once again become acquainted with the architectural photography of the nineteenth century, we should guard against seeing Atget as the last artist of a great tradition.

The history of photography is short but it is long enough to divide into a period of the old masters and one of modernism. And not unlike painting, our greatest admiration in the field of photography belongs to a few old masters who in an inexplicable manner appear to us as misfits of their own time, creating their work for posterity. The most famous examples of such artists, remote and yet familiar, are amongst painters Vermeer and amongst photographers Atget.

Wilfried Wiegand

Plates

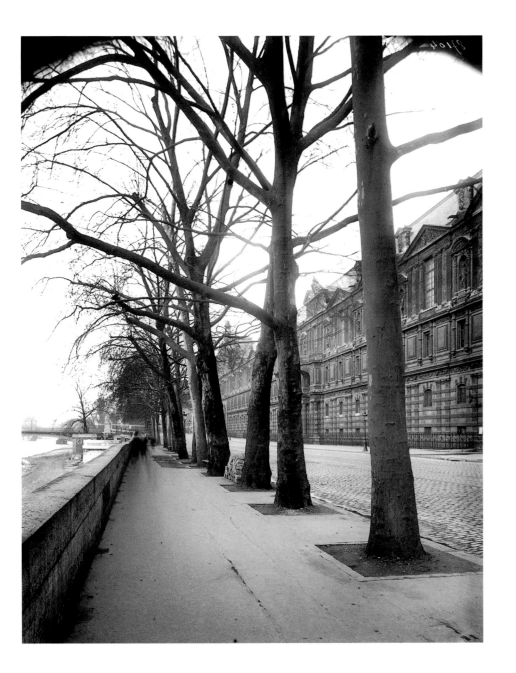

1 Quai du Louvre, 1923

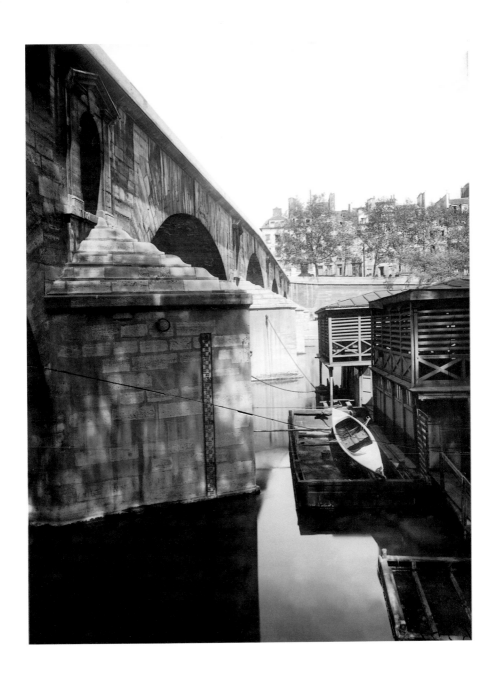

2 Pont-Marie, n.d.

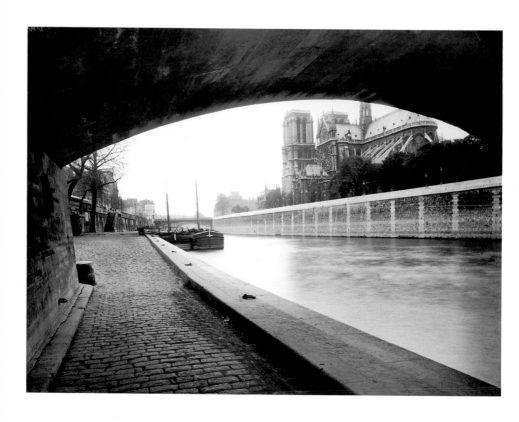

3 Quai de Montebello, pont de L'Archevêché, ca. 1907

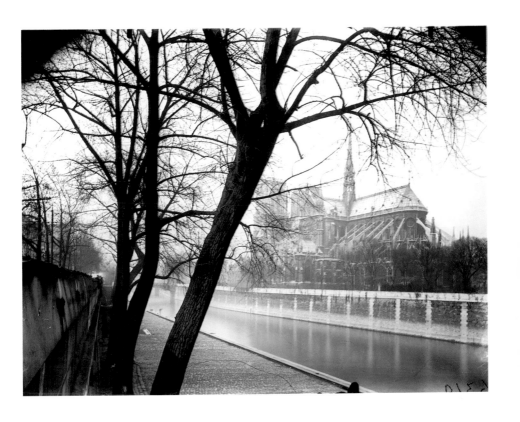

4 Notre-Dame, view from quai de Montebello, 1923

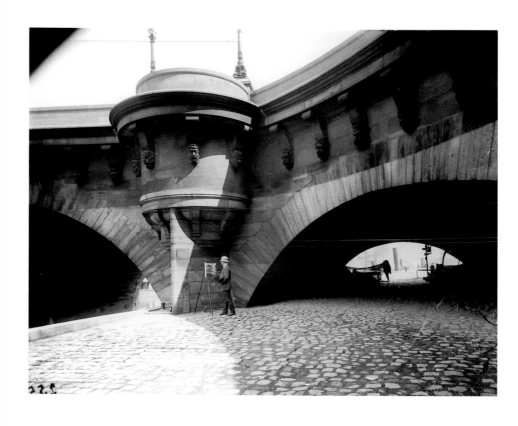

5 Pont-Neuf, quai de Conti, 1908

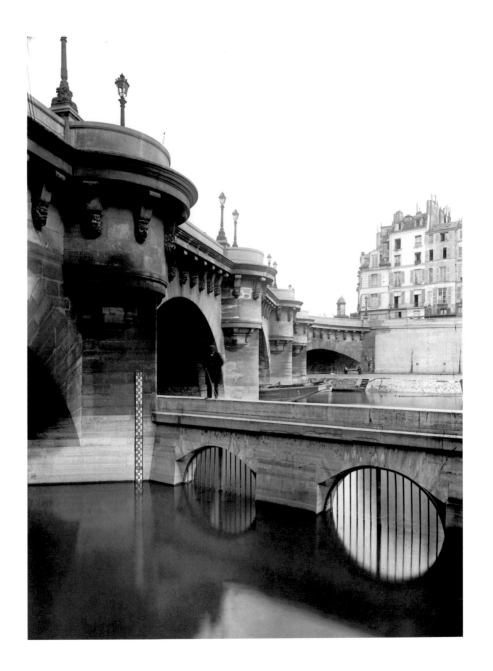

6 Pont-Neuf during a flood, 1908

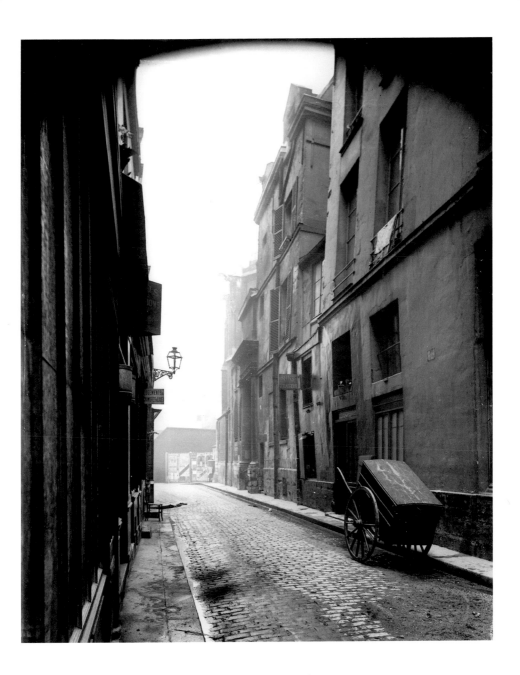

7 Rue des Barres, n.d.

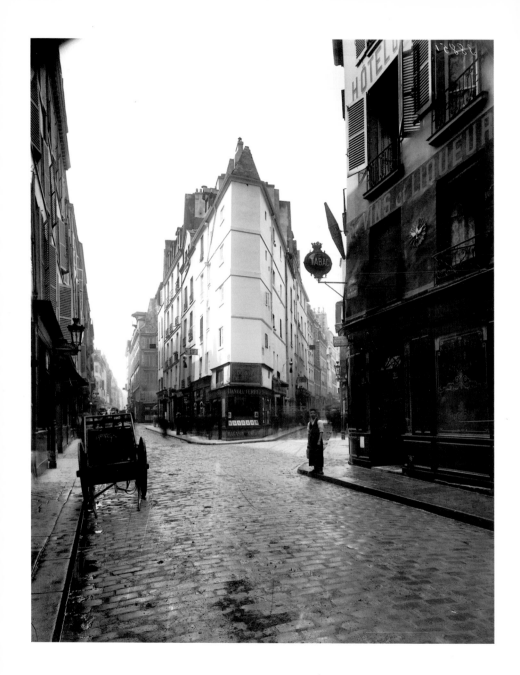

8 Corner of rue de Seine and rue de l'Échaudé, ca. 1910

9 Passage du Pont-Neuf, today rue Jacques-Callot, March 1913

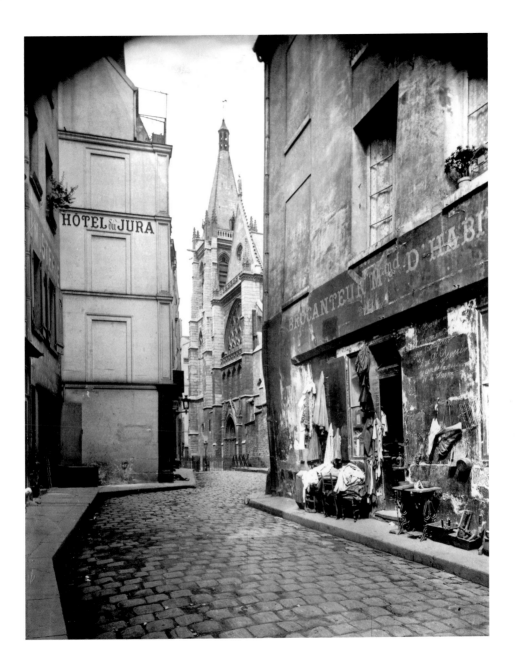

10 Rue des Prêtres-Saint-Séverin, 1903

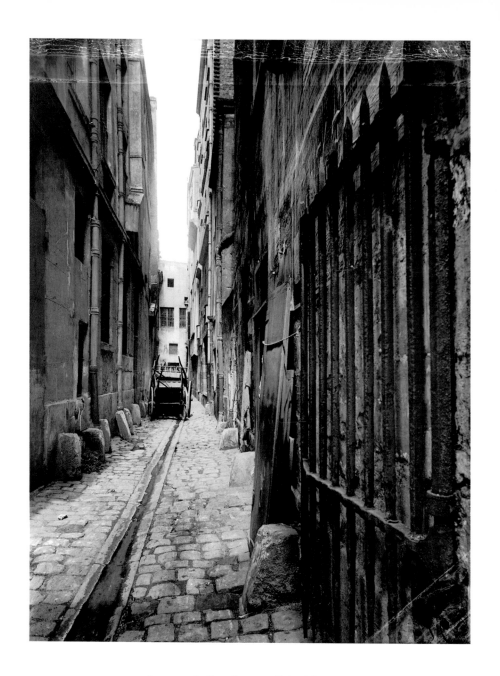

11 Impasse du Bœuf, 10 rue Saint-Merri, 1908

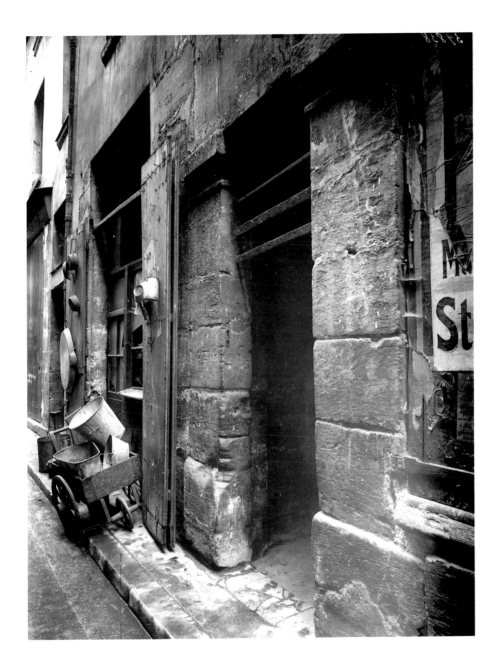

12 5 rue de la Reynie, 1912

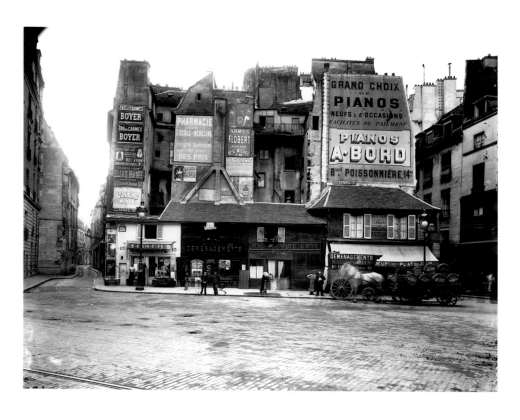

13 Place Saint-André-des-Arts and rue Suger, 1903

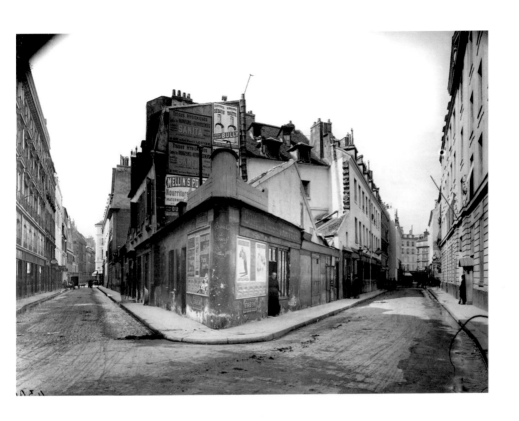

14 Corner of rue de Penthièvre and avenue Matignon, n.d.

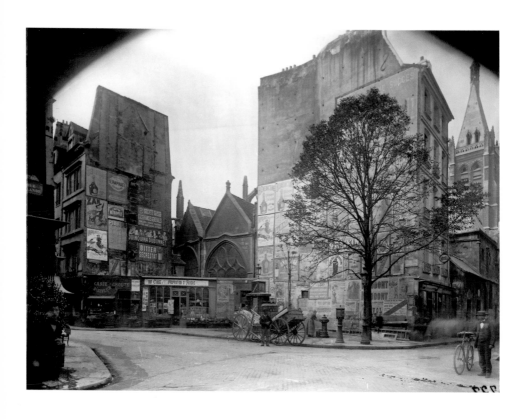

15 Église Saint-Séverin, view from the corner of rue Saint-Jacques
and rue Galande, September 1899

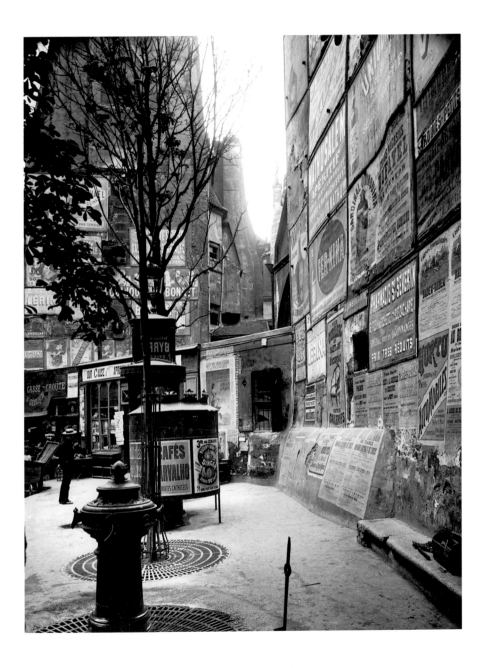

16 Rue Saint-Jacques, corner of rue Saint-Séverin, ca. 1900

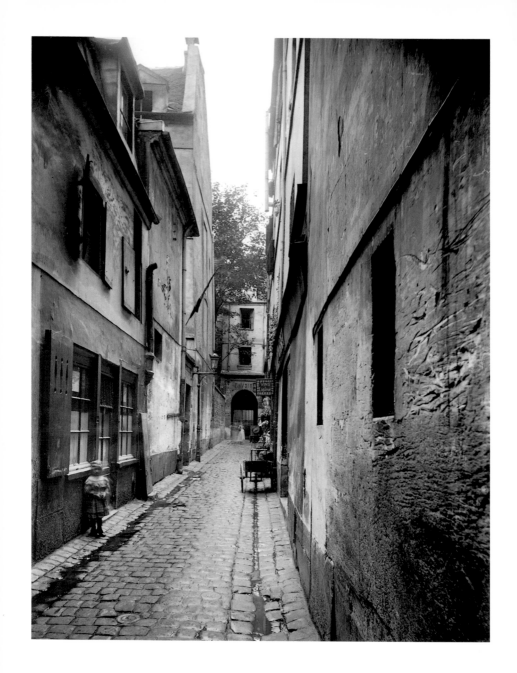

17 Passage Saint-Pierre, September 1899

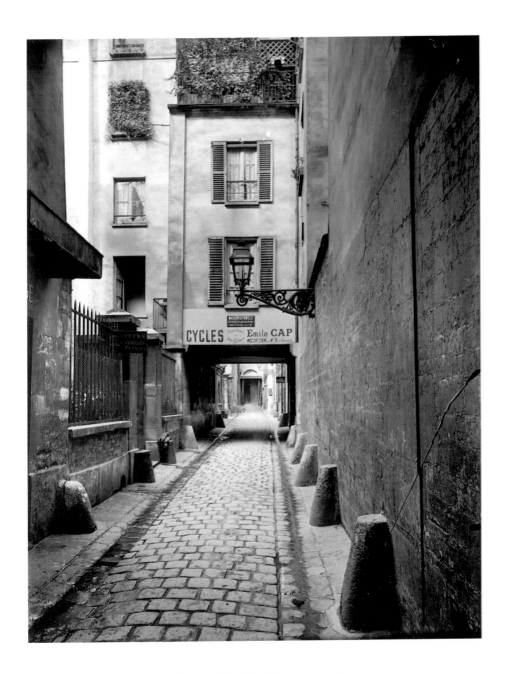

18 Passage Saint-Paul, September 1899

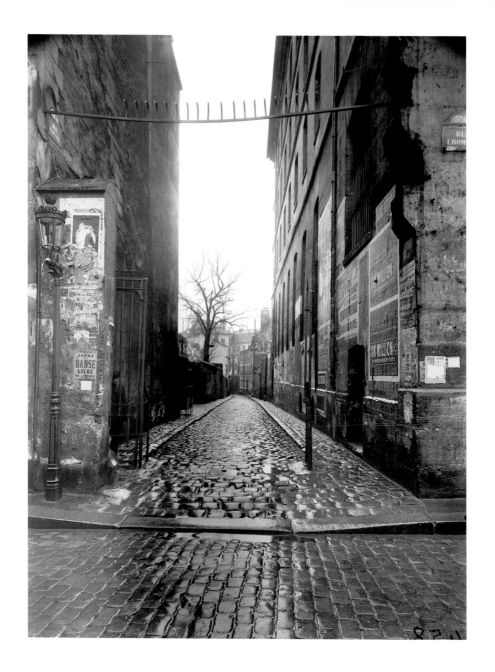

19 Corner of rue Lhomond and rue Rataud, 1913

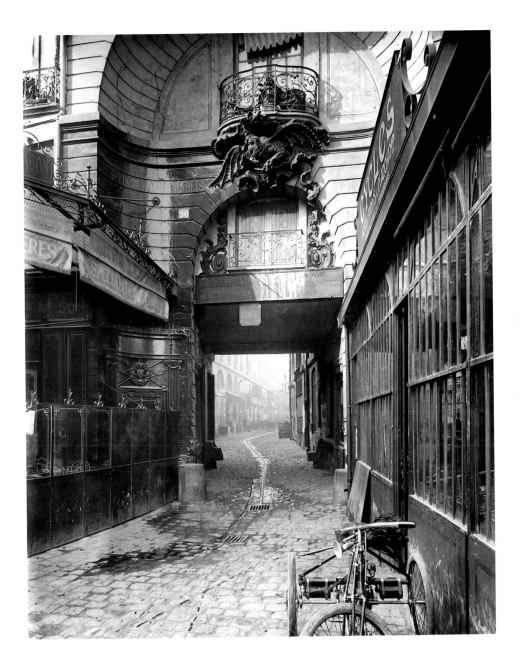

20 Cour du Dragon, 50 rue de Rennes, n.d.

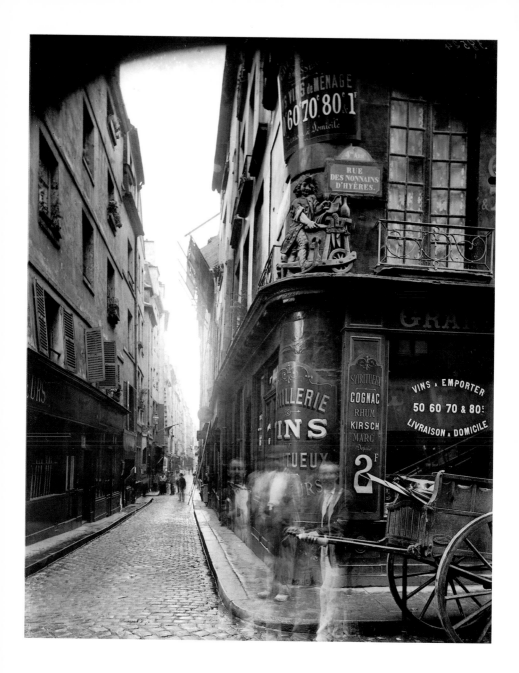

21 Rue des Nonnains-d'Hyères, 1899

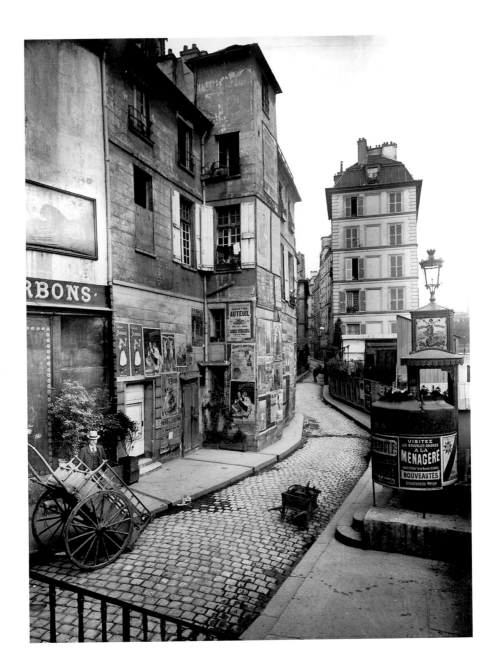

22 Rue des Ursins, 1900

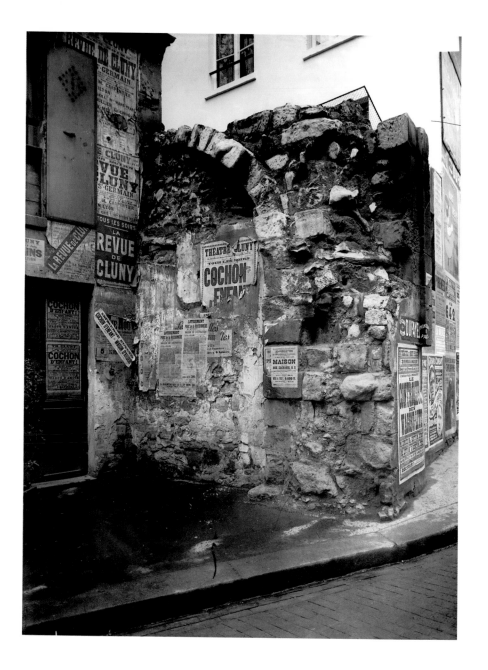

23 Hospice des Mathurins, remains of the chapel, 1909

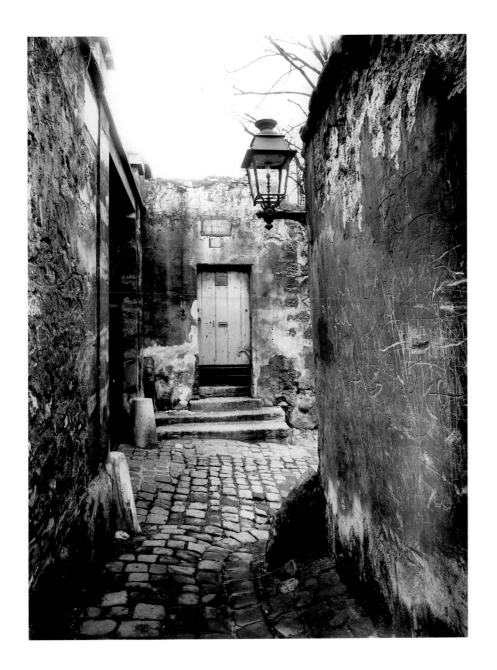

24 18 rue Berton, n.d.

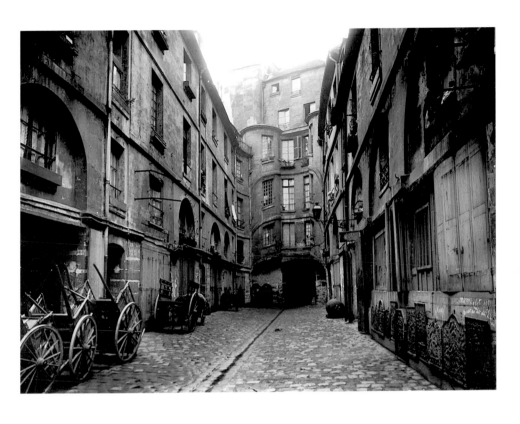

25 Cour du Dragon, 50 rue de Rennes, n.d.

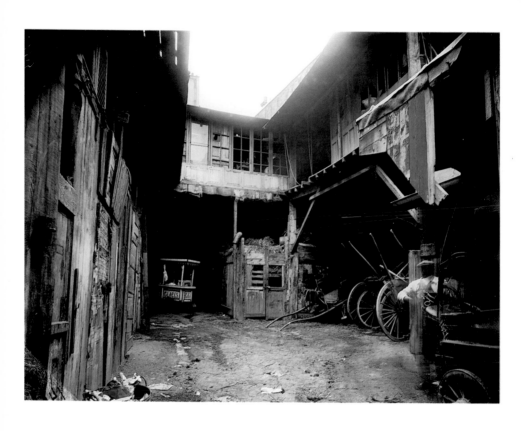

26 Courtyard, 1913

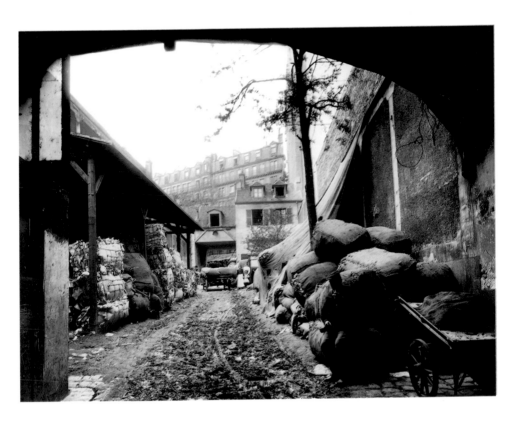

27 A ragman's courtyard, 16 rue de l'Amiral-Mouchez, 1913

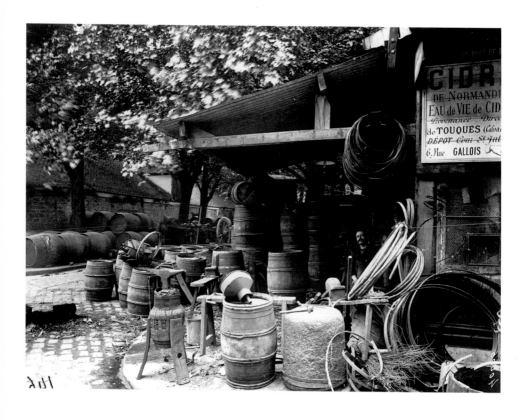

28 Corner of rue du Port-de-Bercy and rue Léopold, n.d.

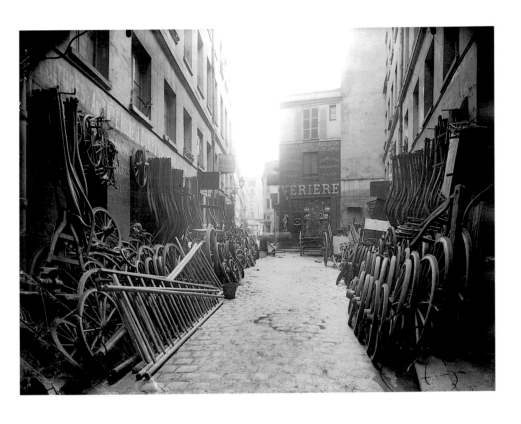

29 Cour Damoye, 12 place de la Bastille, n.d.

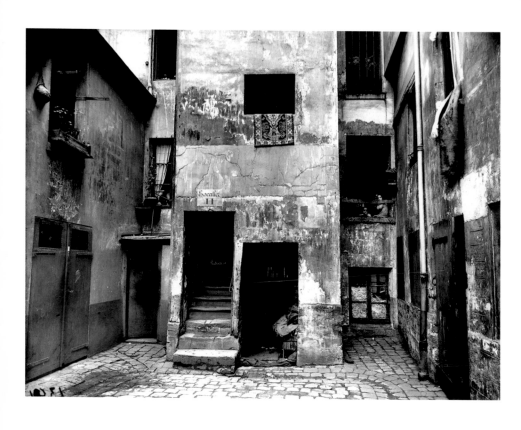

30 Courtyard, 41 rue Broca, n.d.

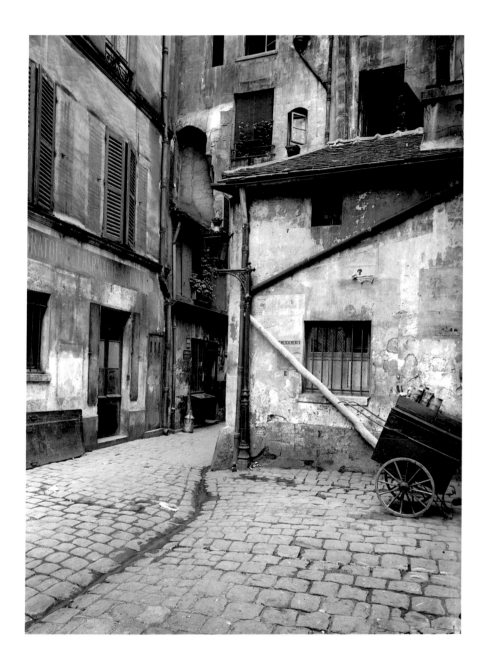

31 Entrance to the cimetière Saint-Paul, passage Saint-Pierre, 1899

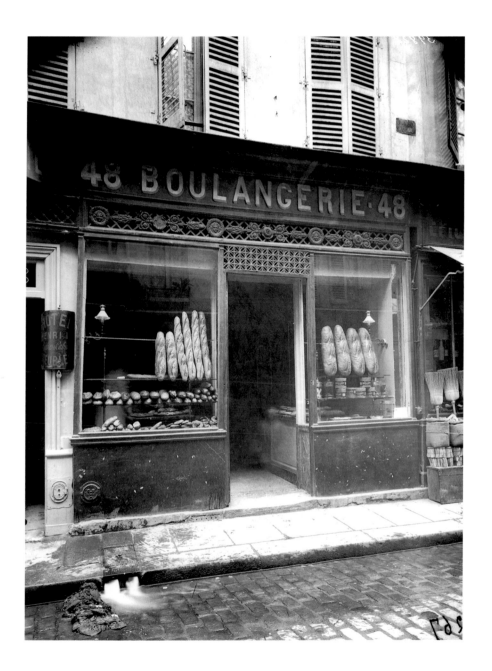

32 Boulangerie, 48 rue Descartes, n.d.

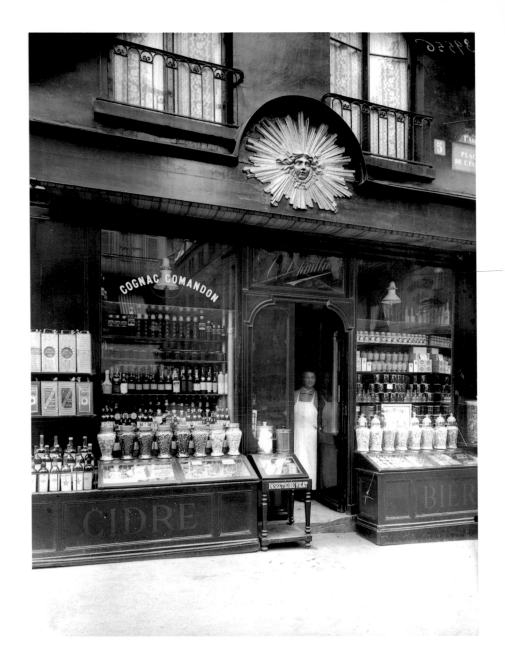

33 "Au Soleil d'Or," 5 place de l'École, before 1905

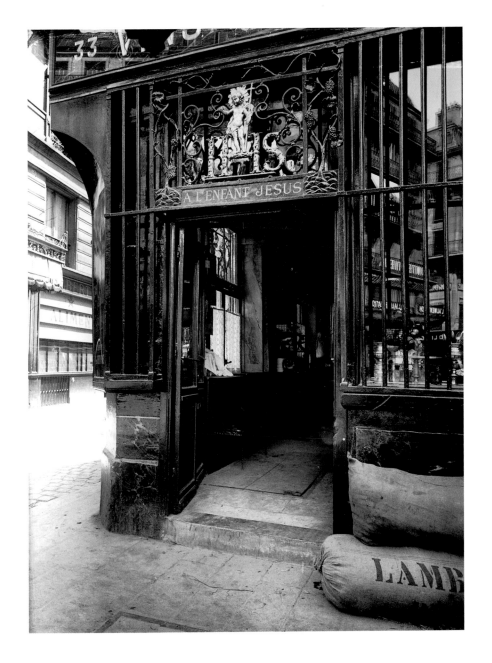

34 "À l'Enfant Jésus," 33 rue des Bourdonnais, 1900

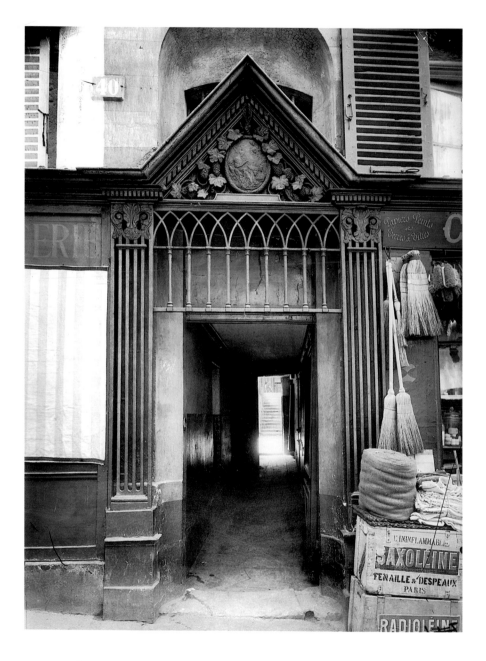

35 "À Sainte-Geneviève," 40 rue de la Montagne-Sainte-Geneviève, 1909–10

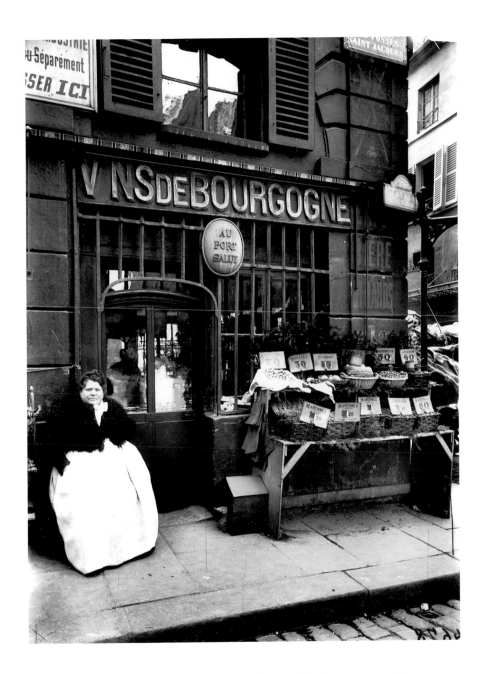

36 "Au Port Salut." 163bis rue des Fossés-Saint-Jacques, 1907–8

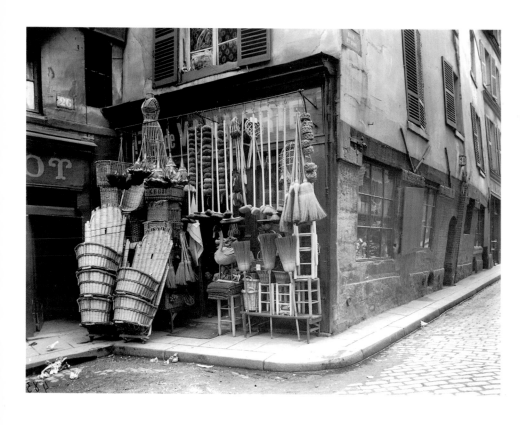

37 Shop, 26 rue Sainte-Foy, 1907–8

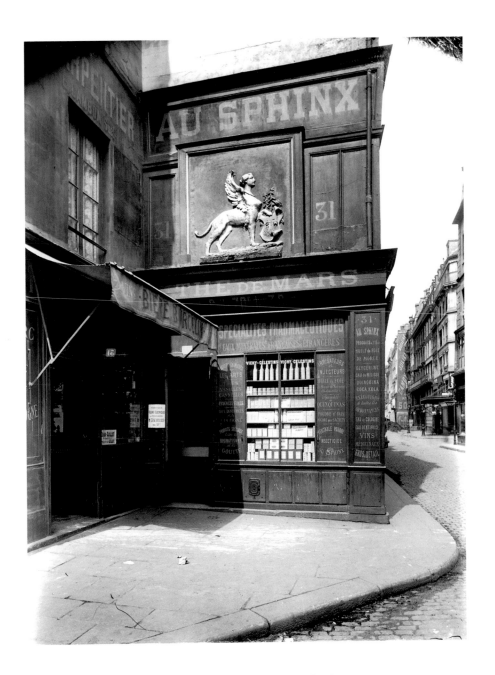

38 Maison du Sphinx, 31 rue Saint-Denis, 1907

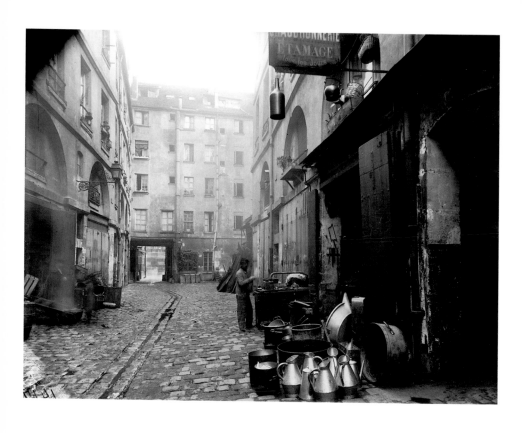

39 Passage du Dragon, 50 rue de Rennes and 7 rue du Dragon, 1913

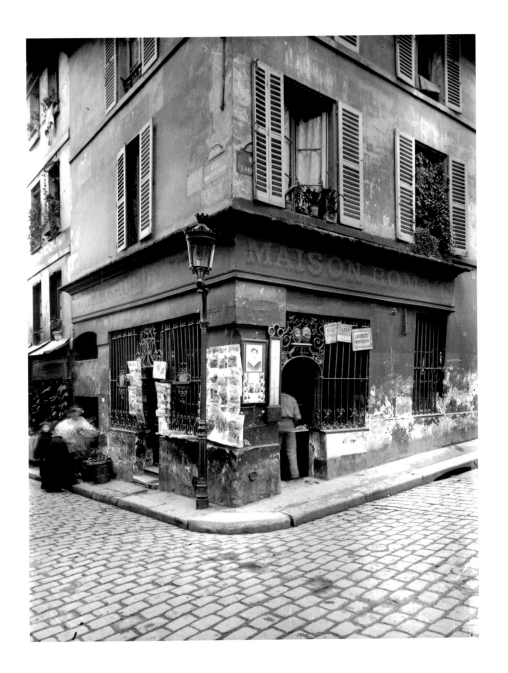

40 Cabaret, rue Mouffetard, demolished in 1907, ca. 1900

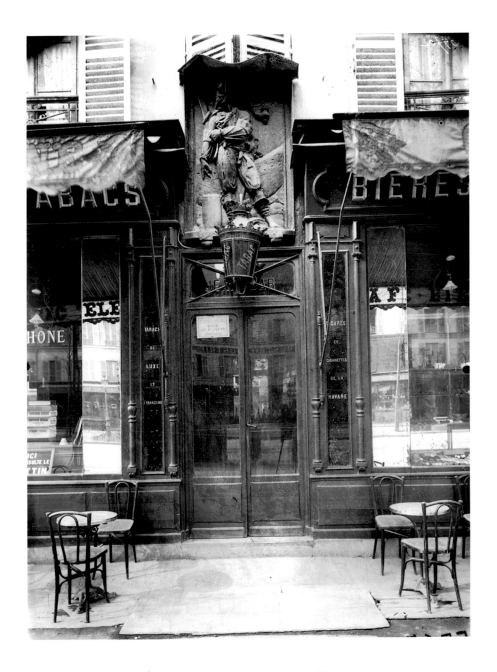

41 "À Jean Bart," 38 avenue Lamotte-Piquet, 1911

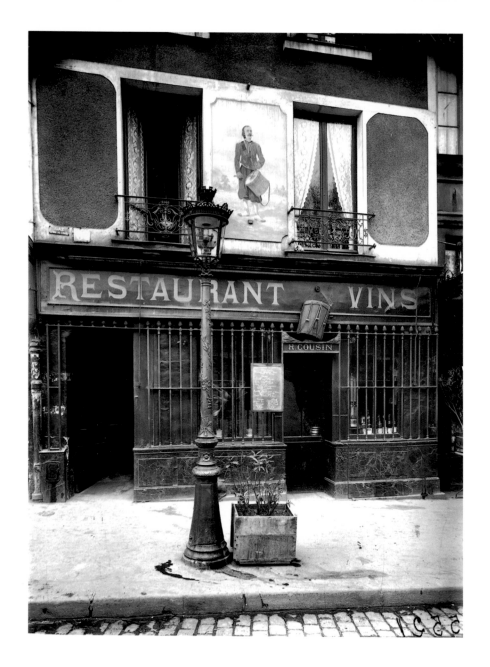

42 "Au Tambour," 63 quai de la Tournelle, 1908

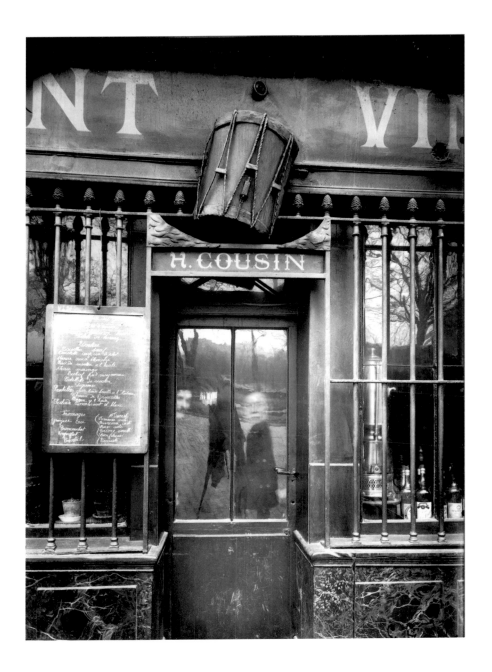

43 "Au Tambour." 63 quai de la Tournelle, 1908

44 "Au Petit Bacchus," 61 rue Saint-Louis-en-Île, 1902

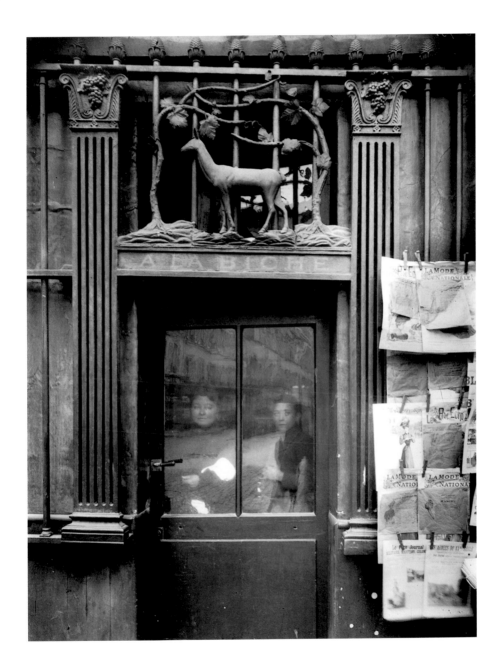

45 "À la Biche," 35 rue Geoffroy-Saint-Hilaire, 1904–5

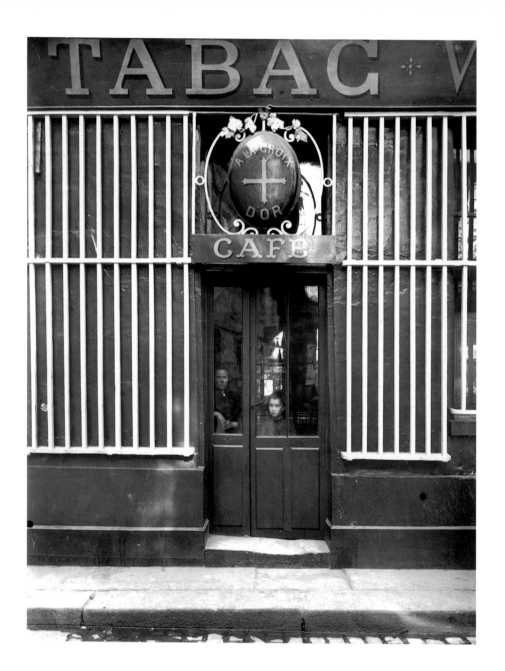

46 "À la Croix d'Or," 54 rue Saint-André-des-Arts, closed in 1911, 1911

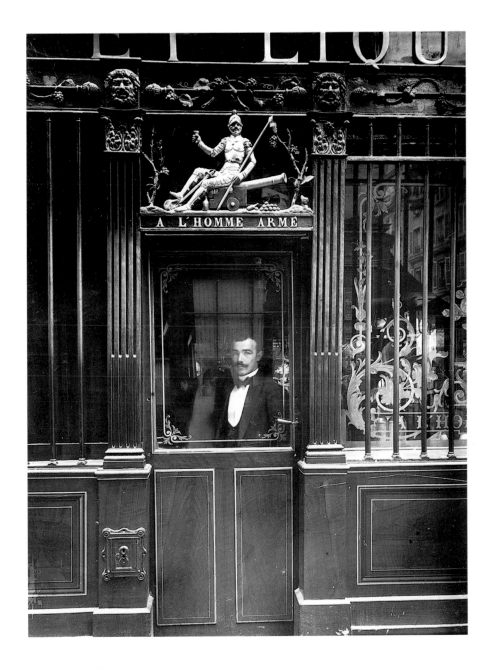

47 "À l'Homme armé," 25 rue des Blancs-Manteaux, September 1900

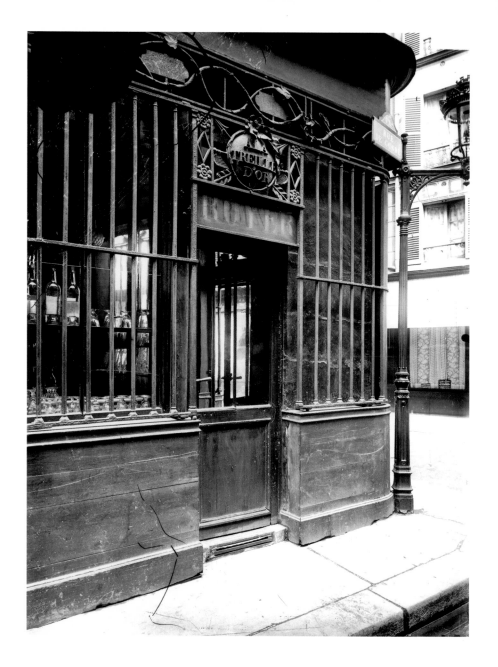

48 "À la Treille d'Or," 6 rue de Condé, 1900

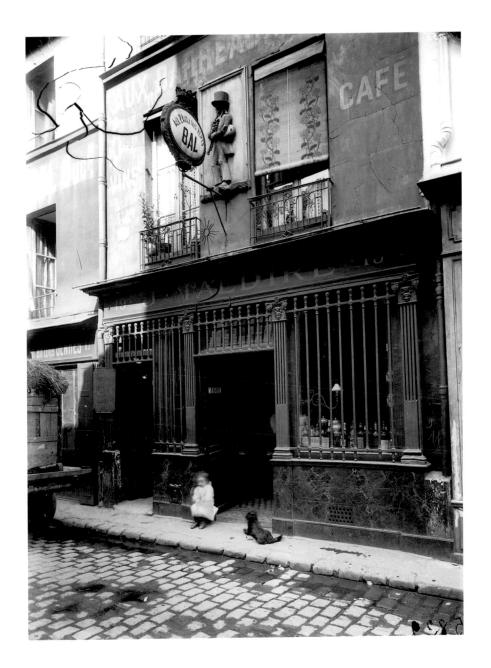

49 "Au Joueur de Biniou," 19 rue de Lappe, 1911

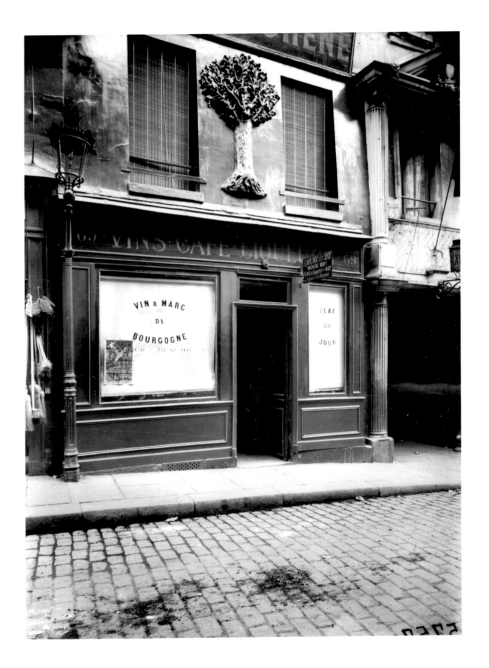

50 "Au Vieux Chêne," 69 rue Mouffetard, 1911

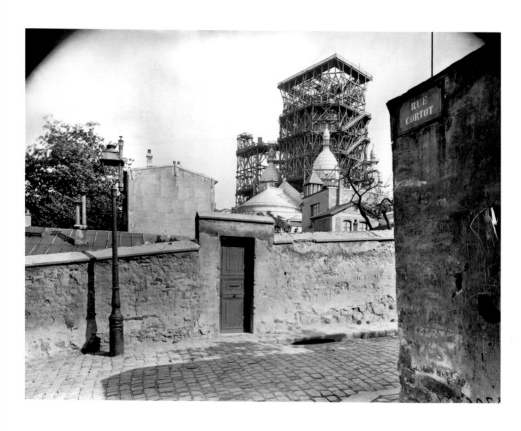

51 Rue Cortot, 1899

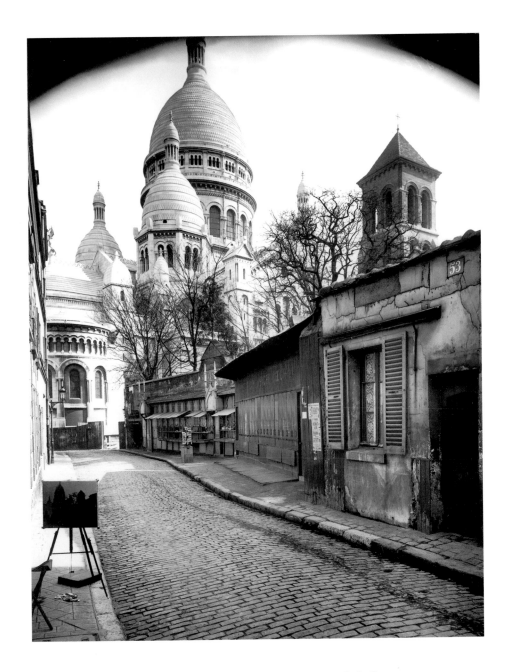

52 The Sacré-Cœur Basilica, view from rue Chevalier-de-la-Barre, ca. 1920

53 Ragmen, boulevard Masséna, 1913

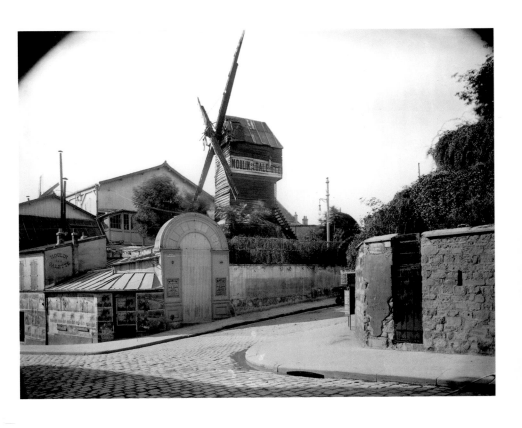

54 "Le Moulin de la Galette," rue Lepic, 1899

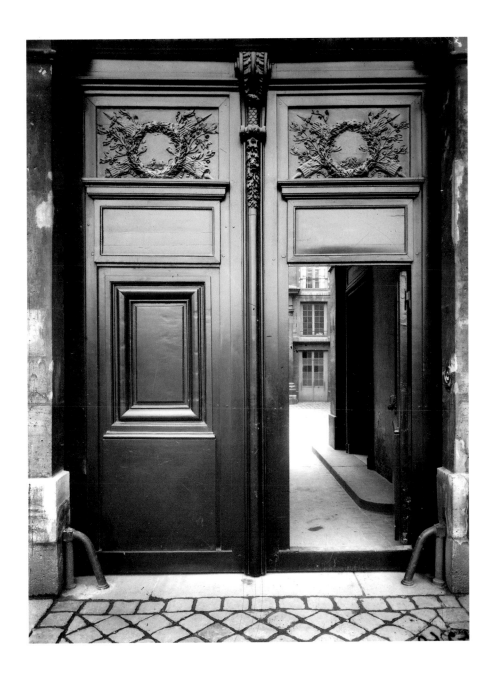

55 Palais de l'Institut de France, 21–25 quai de Conti, 1905

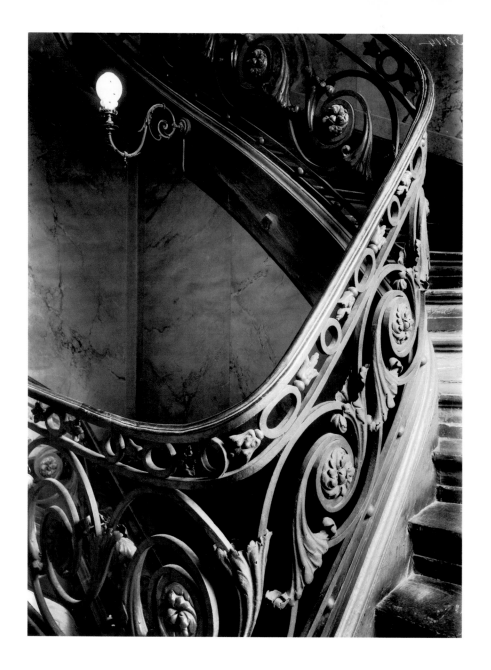

56 Hôtel de Sully-Charost, 11 rue du Cherche-Midi, 1904–5

57 91 rue de Turenne, 1911

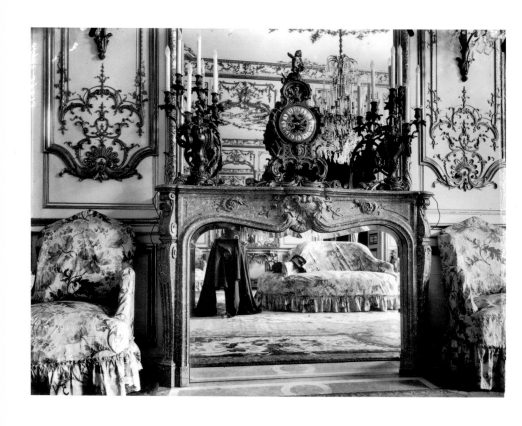

58 Hôtel Matignon, Austrian embassy, today the offices of the Prime Minister,
57 rue de Varenne, 1905

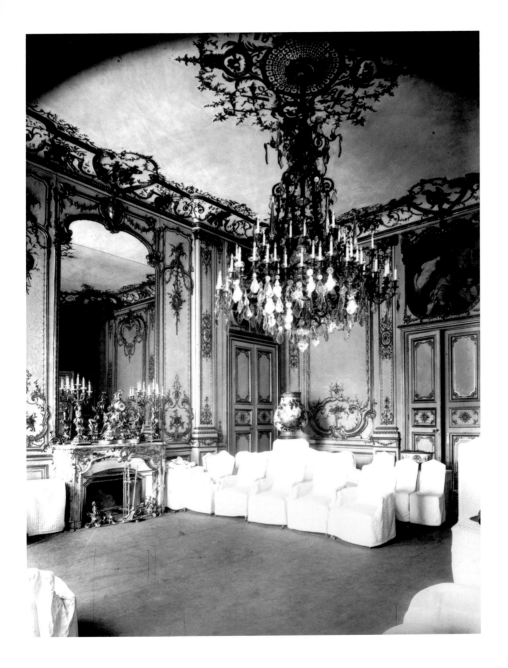

59 Hôtel de Roquelaure, State Ministry of Public Works,
246 boulevard Saint-Germain, 1905

60 Hôtel Matignon, Austrian embassy, today offices of the Prime Minister, 57 rue de Varenne, 1905

61 Palais-Royal, 1904

62 Saint-Cloud, 1924

63 Saint-Cloud, 1921–1922

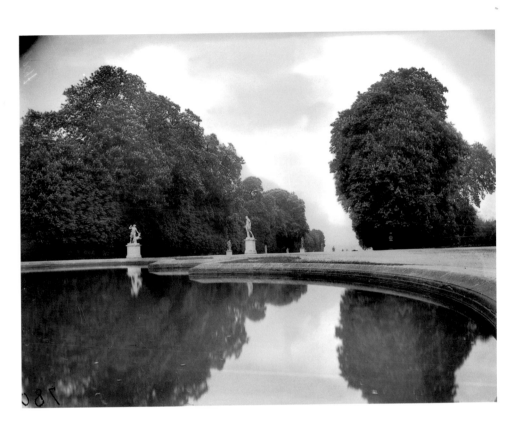

64 Saint-Cloud. 1915–1919

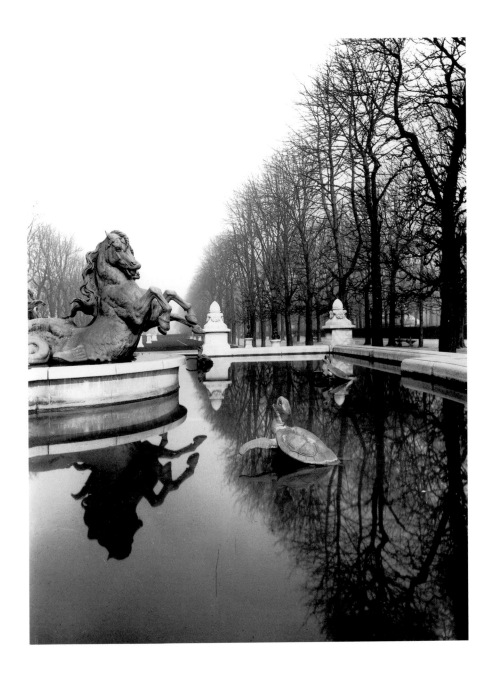

65 Jardin du Luxembourg, Carpeaux Fountain, 1901–2

Chronology

1857 Jean-Eugène Atget is born on 12 February to Jean-Eugène Atget, coach-builder, and Clara-Adeline, née Hourlier, in Libourne (Gironde).

1859 The family moves to Bordeaux. His father becomes a traveling salesman.

1862 Father dies and his mother shortly thereafter.
Atget is subsequently raised by his maternal grandparents. As a young man he may have gone to sea.

1878 In Paris Atget applies for entrance to the state acting academy but is rejected. He begins his military service.

1879 In a second attempt he is accepted at the academy, where he studies under the outstanding actor Edmond Got.

1881 He is dismissed from the academy for insufficient progress. Continues his military service. His grandparents die.

1882 Owing to the loss of his family he is released from his military duties a year early. He settles in Paris at 12 rue des Beaux-Arts. Works as an actor but only in minor roles in the suburbs of Paris or in the country. As a member of a traveling troupe, he no longer resides in Paris. Atget meets André Calmettes, who becomes his friend and later the executor of his estate.

1886 Meets the actress Valentine Compagnon, who is ten years older. She brings a son (1878–1914) into their life-long relationship but has no children with Atget.

1887 Gives up acting, according to his own account, because of an illness affecting his vocal cords. He retains his passion for the theater during his entire life.

1888–89 During these obscure years in his life, Atget presumably lives in the provinces, where he takes up photography. His first known photos are of Amiens and Beauvais.

1890 Settles again in Paris, at 5 rue de la Pitié. Unsuccessful as a painter, he decides to work as a professional photographer, affixing the sign "Documents pour Artistes" to his door.

1892 Places an announcement in the *Revue des Beaux-Arts*, in which he offers his services as a photographer of paintings and, in particular, for artists interested in photographic documents as models.

1897 Begins to photograph Paris in a systematic manner. The first photos for his

	series "Petits Métiers de Paris" are taken. A Parisian company publishes eighty postcards of Atget's photos of street vendors.
1898	Sells his first photos to public collections in Paris, for example, to the Musée Carnavalet.
1899	Moves to 17bis rue Campagne-Première on Montparnasse, where he remains until his death.
1901–2	He begins his series of door knockers, of "L'art dans le Vieux Paris," and of the Parisian environs.
	Photographs decorative elements on façades, such as balconies and doors.
1903–4	Photos of courtyards, staircases, and churches.
1904–13	Holds lectures on the history of theater. He still considers himself an "ex-artiste des théâtres de Paris."
1905–6	Photos of staircases, chimneys, and the interiors of buildings from the time of the *Ancien Régime.*
1907	Around this time he is commissioned to photograph *Vieux Paris* by the Bibliothèque Historique de la Ville de Paris.
1910	He begins selling albums of photos to the Musée Carnavalet and the Bibliothèque Nationale.
1911–12	He gives a collection of Socialist newspapers to the Bibliothèque Historique de la Ville de Paris.
1914	Valentin Compagnon, son of Valentine Compagnon, dies at age thirty-six; his own son, the last survivor from Atget's intimate circle, lives until 1986.
1917	Atget sells the newspaper articles he has collected since 1896 on the Dreyfus affair to the Bibliothèque Nationale.
1917–18	Atget photographs less and less during the final years of World War I. In order to protect his work from being destroyed by the bombing of Paris, he deposits his negatives in the cellar.
1920	He sells the Ministry of Education 2,621 plates on the themes "L'art dans le Vieux Paris" and "Paris pittoresque"; for these he receives 10,000 francs. In the years thereafter he travels to the outskirts of Paris to photograph the parks of Versailles, Saint-Cloud, and Sceaux.
1921	From March to June he takes photos of prostitutes for the painter André Dignimont.
1926	Four photos by Atget are reproduced, uncredited, in the magazine *La Révolution surréaliste.*
	Valentine Compagnon dies on 20 June.
1927	Berenice Abbott takes three portrait photos of Atget in her studio.
	Eugène Atget dies on 4 August.
	His friend André Calmettes, director of the theater in Strasbourg and a

successful actor in his youth, oversees the photographer's estate. Approximately 2,000 negatives are bought by the Archives Photographiques d'Art et d'Histoire. Berenice Abbott acquires the remaining negatives and prints, and Atget's address book, with the help of the American art dealer Julien Levy.

1928 The "Premier Salon des Indépendants de la Photographie" shows several of Atget's photos, probably from Man Ray's collection.

1929 The exhibition "Film and Photo" in Stuttgart includes eleven photos from Berenice Abbott's collection.

1930 The book *Atget: Photographe de Paris* is published in Paris, Leipzig, and New York, establishing the photographer's fame. The introduction to the French and English editions is by Pierre Mac Orlan, that to the German edition by Camille Recht. The ninety-six photos were selected by Berenice Abbott from her collection.

1968 Berenice Abbott sells her Atget collection, comprising more than 4,000 prints, some 1,300 negatives, and diverse documents, to the Museum of Modern Art in New York.

Select Bibliography

General

Leroy, Jean. *Atget: Magicien du vieux Paris en son époque*. Rev. ed. Paris: Paris Audiovisuel/Pierre Jean Balbo, 1992.

Nesbitt, Molly. *Atget's Seven Albums*. New Haven: Yale University Press, 1992.

Reynoud, Françoise. *Eugène Atget*. Photo Poche, vol. 16. Paris: Centre National de la Photographie, 1995.

Szarkowski, John, and Maria Morris Hambourg, eds. *The Work of Atget*. 4 vols. New York: The Museum of Modern Art, 1981–85.

Memoirs

Abbott, Berenice. *The World of Atget*. New York: Horizon Press, 1964.

Brassaï. "My Memories of E. Atget, P.H. Emerson and Alfred Stieglitz." *Camera* (Lucerne) 18 (January 1969): 4–13, 21, 27, 37.

Levy, Julien. *Memoir of an Art Gallery*. New York: G.P. Putnam's, 1977.

Man Ray. [Interview.] *Camera* (Lucerne) 74 (February 1975): 37–40. Reprinted in *Dialogue with Photography*, edited by Paul Hill and Thomas Cooper, 9–20. London: Thames and Hudson, 1979.

Atget and Architectural Photography

Borcoman, James. *Eugène Atget: 1857–1927*. Ottawa: National Gallery of Canada, 1984.

"Colloque Atget: Actes du Colloque, Collège de France, 14–15 juin 1985." *Photographies*, hors-séries (March 1986): 1–128.

Photographie & Architecture. Monuments historiques, no. 110. Paris: Editions de la Caisse Nationale des Monuments Historiques et des Sites, 1980.

Thézy, Marie de. *Charles Marville*. Photo Poche, vol. 65. Paris: Centre National de la Photographie, 1996.

Abbott, Berenice. "Eugène Atget" (1929). Reprinted in *Photography: Essays and Images. Illustrated Readings in the History of Photography*, edited by Beaumont Newhall, 234–37. New York: The Museum of Modern Art, 1980.

Benjamin, Walter. "The Work of Art in the Age of Mechanical Reproduction." Translated by Harry Zohn. In *Illuminations*, edited by Hannah Arendt, 217–51. New York: Schocken, 1968.

Benjamin, Walter. "A Short History of Photography." Translated by Phil Patton. *Artforum* 15 (February 1977): 46–51.

Desnos, Robert. "Émile Adjet" (1929). Reprinted in *Nouvelles Hébrides et autres textes, 1922–1930*. Paris: Gallimard, 1978.

Mac Orlan, Pierre. *Atget: Photographe de Paris*. Paris: Henri Jonquières, 1930; New York: Erhard Weyhe, 1930.

O'Neal, Hank. *Berenice Abbott: American Photographer*. New York: McGraw-Hill, 1982.

Recht, Camille. *Atget: Lichtbilder*. Paris and Leipzig: Henri Jonquières, 1930. Reprinted with an afterword by Dietrich Leube and edited by Gabriele Forberg. Munich: Rogner & Bernhard, 1975.

La Révolution surréaliste (1924–1929). Reprinted with a foreword by Georges Sebbag. Paris: Jean-Michel Place, 1975.

Weston, Edward. *The Daybooks of Edward Weston*. Edited by Nancy Newhall. Vol. 2, *California*. Millerton, N.Y.: Aperture, 1973.

Selections of Atget's Photographs

Beaumont-Maillet, Laure, ed. *Atget: Paris*. Paris: Hazan, 1992.

Le Gall, Guillaume, ed. *Atget: Paris pittoresque*. Paris: Hazan, 1998.

Nesbit, Molly, and Françoise Reynaud, eds. *Eugène Atget: Intérieurs parisiens. Un album du Musée Carnavalet*. Paris: Éditions Carré, 1992.

Reynaud, Françoise, ed. *Les Voitures d'Atget au Musée Carnavalet*. Paris: Éditions Carré, 1991.

Trottenberg, Arthur D., ed. *A Vision of Paris: The Photographs of Eugène Atget, The Words of Marcel Proust*. New York: Macmillan, 1963

Cover illustrations
Eugène Atget, *Cour du Dragon, 50 rue de Rennes*, n. d.
Berenice Abbott, *Eugène Atget*, 1927

Published in the USA and Canada
by te Neues Publishing Company, New York

Translated from the German by Anne Heritage.

© of this edition 1998 by Schirmer/Mosel, Munich

This work is protected by copyright. Any form of reproduction or communication
of this work or of parts thereof – in particular the reproduction of text or pictures,
recitation, performance and demonstration – is only permissible within the scope of
copyright law. This also applies to all other forms of usage, such as translation,
reproduction of diagrams, cinematographic adaptation, or radio and
television broadcasting. Infringements will be prosecuted.

Typeset by Typograph, Munich
Printed and bound by EBS, Verona

ISBN 3-8238-0363-8
A Schirmer/Mosel Production

An Everyday God

Insights from the Ordinary

More books by James Taylor

Everyday Pslams:
The Power of the Psalms in Language and Images for Today

Everyday Parables:
Rediscovering God in Common Things

Sin:
A New Understanding of Virtue and Vice

Precious Days & Practical Love:
Caring for Your Aging Parent

Table of Contents

7 Acknowledgments

8 Using this book

11 Preface

Chapter 1
When God Got Lost

Too many people today locate God in a building or a book. Here's how to change that.

19

Chapter 2
Glimpses of Glory

Learning to recognize the moments when God breaks through to us. With ten stories for daily study or devotional use.

27

Chapter 3
Seeing the Whole Story

The Bible should be read as the beginning, not the final word, of a continuing story – 13 stories.

61

Unexpectedly, something from the Bible or Christian doctrines can help in understanding the present – 11 stories.

Chapter 4

Insights from Yesterday 105

Sometimes a current experience helps faith problems pop into focus – 13 stories.

Chapter 5

Clues from Today 143

Living in partnership can be a joy not a burden.

Chapter 6

Towards an Everyday God 187

Index of Seasons and Themes 190

Acknowledgments

A book is never the work of one person and this book is no exception. Many people have assisted in it.

(from the original edition first published in 1981 by Wood Lake Books)

My thanks especially go to Norman Vale, the former press relations officer for the United Church of Canada, who first encouraged me to start writing for the syndicated column "Words to Live By."

The church's Division of Mission in Canada gave me permission to revise and adapt many of the stories first published as "Words to Live By" columns; Norman MacKenzie and Gordon Turner gave theological oversight and helped clarify fuzzy thinking; Gordon Freer read my draft manuscript and suggested the book's title.

And I am now, and always will be, deeply grateful to Ralph and Bev Milton. As founder of Wood Lake Books, Ralph was the first to see enough potential in *An Everyday God* to take the risk of publishing it. But he also insisted that I re-organize, and partially rewrite, the book to bring out that potential. Bev Milton tested various chapters in the congregation she was serving. If *An Everyday God* proves helpful to you in the growth of your faith, much of the credit goes to Ralph and Bev.

Lastly, a word of gratitude must go to my own family, who allowed themselves to be written about occasionally, who tolerated both the long evenings spent working on the manuscript and the seemingly permanent mess on the dining room table, and who provided criticism that was always constructive.

Using this book

A book of devotions should be both simple and profound. It should move the heart and challenge the mind without getting caught on the hooks of jargon and abstraction.

As a layperson, Jim Taylor understands the need for simplicity. As a theologian, he understands the need to be biblical and precise. As a journalist, he has learned how to be interesting and colorful.

Because of this, *An Everyday God* is a powerful series of personal meditations. The 47 devotionals make it ideal for use as a Lenten series of devotions. But the clear language and vivid word-pictures also make it a delightful source of meditations for small groups, with subjects to fit all the seasons of the year. And clergy will find this book a gold mine of sermon illustrations.

That's why *An Everyday God* will undoubtedly be used in as many different ways as there are readers.

Some people will simply sit down and read it for pleasure or personal nurture. There's plenty in the book for both.

Most of us will find so much food for thought in each item we will want to take it more slowly and use it as a series of devotional readings. Jim has designed the book with that in mind. You'll find the devotional pieces in chapters 2 through 5.

If you're using this book for private devotions, we'd suggest you locate the Bible passages before you begin. They are listed at the end of each piece. We recommend a contemporary translation of the Bible such as the Good News Bible or the New Revised Standard Version.

Prayer is the central part of any meditation. It needn't be anything formal – just a conversation with a friend. A little technique that's helped many people who are learning to pray: set a chair beside you and imagine that God (or Jesus if you prefer) is sitting there with you, as in a real sense he is. Then with your eyes closed, whisper so that only the two of you can hear.

If you are using material from this book to lead in group devotions, you'll certainly need a different style. In this case, after one person has read the Bible passage and perhaps another has read the meditation, someone should read the suggestions for prayer. This should be done in a quiet tone, with enough pauses so that people have time to do their own meditation. The idea is to provide people in your group with guidance for prayer, without doing their praying for them.

It would be good for the leader to check the meditation and the Bible reading in advance to decide which should come first.

One last suggestion. The stories Jim tells may bring some of your own stories to mind. That's why we also suggest that your group have a chance to share any feelings they may have or questions they may wish to raise.

Whatever way you use this book, we hope it's as meaningful and useful to you as it was to me, and that you too will rediscover an everyday God.

~ RALPH MILTON

Preface: Empathy

Every so often, religious faiths reform themselves. I feel privileged to be taking part in one of those reformations.

Unlike previous reformations – which include the Protestant Reformation, but also later reformations within both Catholicism and the Protestant church, and which have similarly happened within Buddhism, Hinduism, and Islam – this one doesn't have a name yet, perhaps because it has had no definable leader. But it is happening.

I didn't know I was taking part in a reformation when I first wrote *An Everyday God*. Indeed, I had only recently become a convert to inclusive language. Until then, I had ridiculed inclusive language – and the mindset that goes along with it. But through a gradual accumulation of experiences and insights, I realized that traditional male-oriented metaphors ignored, hurt, or excluded half of the human race. When a society treats only the male experience as the norm, it penalizes itself by turning a deaf ear to the wisdom of half its members.

So as I edited the collection of columns that eventually became *An Everyday God*, I worked hard at avoiding sexist language, especially for God.

The effort won a backhanded compliment soon after the book was published in 1981. A woman told publisher Ralph Milton, "I'm so glad you folks aren't using that silly inclusive language!" We were – but we had carefully

JAMES TAYLOR

avoided the complicated "his or her" constructions that drew attention to this new way of thinking.

I cite language, because language is a symbol of this religious reformation.

During the years following publication of *An Everyday God*, I edited the clergy journal *PMC: Practice of Ministry in Canada*. I discovered that different denominations had characteristic writing styles. Lutherans frequently started with a historical overview, often citing Martin Luther himself. Catholics tended to invoke creedal truths. Evangelicals quoted scripture. And feminists almost universally started with a personal experience of some kind.

It was, I was assured, typical of feminist theology. It starts with experience; it moves on to reflection; it ends with action. It is, in that sense, similar to some schools of clinical pastoral education, which treat the "human document" as more important than academic printed documents.

I was surprised to discover that I had been writing feminist theology in *An Everyday God* without knowing it. As you will discover, almost every article in this book starts with experience.

Richard Holloway, who was then the Bishop of Edinburgh, wrote in his book *Doubts and Loves* about returning home from the 1998 Lambeth Conference of bishops of the worldwide Anglican communion wondering if he could

12

still call himself Christian. He found himself appalled at the venom expressed by African bishops towards feminism and homosexuality. The fact that they based their animosity on biblical texts particularly disturbed him. He realized that he now read the Bible with a different perspective from theirs, and indeed from the way that he himself used to read it. For him, he concluded, that difference resulted from exposure to feminist theology.

Feminist theology is not about replacing male metaphors for God with female ones, though that may happen. Nor is it about rejecting the authority of the Bible and of traditional teachings, though that may also happen.

At its root, feminist theology (and its parent, liberation theology) is experiential. It calls the reader to enter into the experience of another.

I've been told that *An Everyday God* changed the way Canadians do theology. A theology student told me he had been about to give up on the excessively academic approach taken at his seminary, until he read *An Everyday God*, and discovered a different style of religious expression. Another minister (now dead of cancer, sadly) said, "At college we were taught to look up what Barth or Tillich had said about a particular text. My generation wants to know what Jim Taylor said about it!"

If *An Everyday God* has had that effect, it is because it focused on the relationship between personal experi-

ence and faith. I have joked – but now consider it almost a truism – that there are two kinds of Christians: those who accept the Bible as true if it corresponds to their own experience; and those who accept their own experience as true if it corresponds to something in the Bible.

My comment may be facetious, but I think it captures the distinction Marcus Borg makes in his book *The Heart of Christianity* between what he calls "the earlier paradigm" and the "emerging paradigm." (Although I agree with his analysis, I wish he could have found more exciting terminology.)

If I dare summarize his thesis, the "earlier paradigm" works in absolutes. The Bible has divine authority in all contexts; faith is a series of biblically based affirmations; morals and ethics are invariable and inflexible, focused on personal salvation in a better afterlife. Its typical reaction (to almost anything) is judgment.

The "emerging paradigm" is metaphorical. It treats stories as stories, not as eternal truths. It doesn't particularly care if the Bible is literally factual, if Jesus was physically resurrected, or if the writers of the Nicene Creed were unrepentant misogynists. The Bible is a human response to the experience of encounters with God. The important thing is how these stories transform your life and your

relationship with God. Its typical reaction is a feeling of community with the experience of others, past and present.

Sometimes, when I lead study groups, I ask participants to agree to a covenant. It says, in part, that each person's experience is just as valid as everyone else's. So you may, if you wish, probe someone else's experience. You may question the conclusions the other person derives from that experience. But you cannot challenge the validity of the experience itself.

That simple agreement eliminates a lot of scriptural proof-texting intended to prove the other person wrong.

Because you can only enter into another's experience if you first accept its validity. The experience of poverty. Of isolation. Of disability. Of being gay or lesbian. Of being male or female. Of being an immigrant, a widow, a child.

This is empathy – the willingness, and the desire, to imagine how you might feel in another's experience. Empathy is more than compassion. Compassion implies feeling pity for others, and wanting to help them be more like us. But "they" aren't us. True empathy invites us to enter their lives, their hopes, their dreams. Then, perhaps, we can help them be who they are.

In its broadest sense, "they" need not even be human. We can imagine the plight of whales run down by ocean tankers, old growth forests felled by chain saws, foxes harried by frenzied hounds...

For me, empathy is the central tenet of this new reformation.

Empathy is not a new concept. Every world faith has a saying somewhat like what we call the Golden Rule: "Do unto others as you would have them do unto you" (Matthew 7:12, Luke 6:31). It's found in the Bible as far back as Leviticus: "You shall love your neighbor as yourself" (Leviticus. 18:19), which Jesus quoted in discussion with teachers of the law. Many of Jesus' teachings and parables reflect the same theme. The Parable of the Sheep and the Goats (Matthew 25:31–46) clearly argues that the way we treat our fellow humans demonstrates our faithfulness.

In his own actions, Jesus demonstrated empathy. To the woman in protracted menstruation whose flow of blood had made her a social outcast for 12 years. To the children who wanted to play. To a woman caught in adultery. To the crippled man who couldn't pitch himself into the bubbling waters of a pool in time to get healed. To a Gentile woman whose daughter had fits, and to a father whose son had seizures.

I cite these examples from Jesus because, although I believe this new reformation crosses all religions, I happen to belong to the Christian tradition. Although some aspects of Buddhism and Hinduism appeal to me, I was raised and will always consider myself Christian. Like Luther, here I stand; I can do no other.

Biblical documents back to Moses' time tell us to look after the victims and the vulnerable – widows, orphans, and strangers (Exodus 22:21–22). They do not tell us to imagine how that person feels, and respond accordingly.

That's the new development. Your own experience is no longer the norm. Through an act of creative imagination, you put yourself in another's place. In your heart and emotions, you walk a mile in that person's shoes. Whether that "person" is a human being, like us, or perhaps a gray whale, a spotted owl, or an old growth forest.

Empathy asks, "What would I feel like, if I were experiencing that situation?"

That is the reformation that I believe is going on. And I'm proud that *An Everyday God* has been part of it for 25 years.

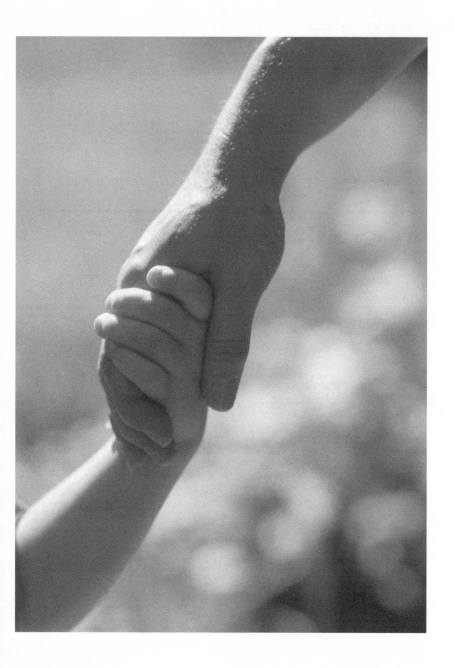

1 ··· WHEN GOD GOT LOST

Why you should read this book

Sociologist Reg Bibby shocked the mainline Protestant churches in the late 1970s with the results of the first comprehensive national survey of religion ever done in Canada.

After years of painstaking research, Bibby found no significant differences in attitudes between church members and Canadians at large.

Specifically, Bibby said, "The religiously committed tend to hold views which...are essentially the same as other Canadians, and...factors such as church attendance do not uniquely contribute to those views."

I was among those startled and depressed by his findings. In hindsight, I realize I shouldn't have been surprised at all. When people exclude from their Christian faith 90 percent of the things to which they devote their time and energy each day, there isn't much opportunity left to be different.

Imagine that someone asked you, "What is God trying to tell you right now?" while you were doing laundry.

Or suppose someone asked you, as you nailed siding onto your house, "What does this tell you about God?"

If you're quick-witted and have memorized a lot of Bible verses as a child, you might come up with word associations about washing away sin, or building houses on a rock.

But until you were asked, it probably wouldn't have occurred to you that what you were doing had any connection with your faith!

And if you were asked the same questions when you were working on the car, or boarding a jumbo jet, you couldn't have answered at all. Because automatic transmissions and airlines are not mentioned in the Bible.

Nor are microwave ovens, or pocket calculators, or outboard motors. They didn't exist when the books of the Bible were being written. So we tend to put them outside the bounds of religion. But we shouldn't. If Jesus were telling parables today, he would talk about those things.

How can I know that? Simply because, in his time, he talked about the things that people were familiar with. He spoke of runaway sons and ungrateful servants, of shepherds and Samaritans. He kept saying, in effect, "God is right here, right now – if you only had the eyes to see, the ears to hear, the minds to think!"

Rarely did Jesus make points by quoting Hebrew history. He didn't want people to look for God in the past. He wanted them to worship a living, everyday God. So he drew his examples from their everyday life and said, "God is like this – only more so."

By and large, though, our churches today have lost the message of Emmanuel, the name that means "God with us." The preaching, the reading, the thinking almost always focus on long long ago. Many Christians today have given up expecting to find God anywhere other than in a church or a book.

That puts their faith into a straitjacket.

It introduces contradictions. So a committee meeting to choose new lights for the church is religious. But a business meeting to improve lighting for working staff is not.

It gives religious virtue to some occupations – such as raising a family, helping the poor and sick, or preaching and teaching. These jobs are all mentioned in the Bible. But running for politics, splitting atoms, or fiddling with a fruit fly's genes, are not. So they're cut off from one's faith.

By failing to look for God today as well as yesterday, by failing to look for God in the world as well as the church, we commit what I am convinced is the dominant heresy of our time. We put limits on God.

We make God a captive of a particular time and space.

We treat God as a heavenly jukebox, that can only repeat forever the same selection of pre-recorded tunes.

We deny God the freedom to do anything new and different. (That's particularly true for those who put the Bible on a pedestal, as God's final word on everything, even if it has never happened before. Interestingly, I've never heard of any who obey Leviticus 25 as the "final word" on pricing policies, or who restore property to its original owner every 50th year.)

The mainline churches today remind me of the disciples before Pentecost. They met behind closed doors, shutting out the society around them. They told and retold stories about Jesus' life and teachings. They tried to reassure themselves that he really had conquered death.

Like the churches today, they looked backwards. They didn't expect God to surprise them.

But God did. The real miracle at Pentecost was not fire, or wind, or speaking in many tongues – it was the discovery that God had not left them alone after all. In a new and different way, God was present.

This book tries to encourage you to use your eyes and ears, your mind and heart, to discover for yourself that God is still present. Not only in religious ceremonies, but when you study the stars or diaper a baby, when you put out the garbage or play touch football. At any time, God may be telling us something new, or helping us understand something old.

If we can see. If we can hear.

Discovering God's presence today means learning to think theologically. We usually avoid theology, because we assume it means rummaging through dusty old books or haggling about how many angels can dance on the head of a pin.

But theology really means thinking about God. Seeing things from a different viewpoint. Asking ourselves, "What does this tell me about God?" and "What is God trying to tell me through this experience?" instead of worrying about how much things cost or what others will think of us.

We need to start recognizing the times when God breaks through the shells of daily routine (Chapter 2).

We need to read the Bible not as the end of God's story, but as the beginning of a story that is still going on (Chapter 3).

We need to use that past to understand our present experiences – and equally important, to let insights from the present illuminate the scriptures and our faith (Chapters 4 and 5).

This book is a selection of some experiences that I have had, that have helped me learn to look for an everyday God. I don't pretend to have had the same experiences as anyone else, or that my experiences are specially important. But I hope that in reading this book you will reflect on your own experiences, and will try some do-it-yourself theology.

Once you start, I think you'll be astonished at how much evidence you'll find of God's presence today. And how much fun you can have finding it.

2··· GLIMPSES OF GLORY

When God breaks through

Have you ever had an experience, a magic moment, when time seemed to stand still? When things seemed crystal clear? When you felt overwhelmed by something beyond yourself?

I have. I suspect almost everyone has, sometime.

Rudolf Otto, a German theologian, coined a word to describe that kind of experience. He called it "numinous," meaning that it goes beyond anything we can rationally describe. Without knowing why, we know that the moment is filled with awe, is overwhelming, is urgent, and is fascinating. We are drawn into it.

The trouble is that we can't explain it. In our culture, being moved to tears seems to be weakness, and being moved to joy like lunacy. So we usually pretend that nothing really happened. We say it was just imagination, just emotion.

But it did happen. And it was real.

Maybe we can't explain these moments. But if we can accept them, if we can admit that they could be God cracking open the crust that forms on our daily routines, we may start to see, hear, and feel the presence of an everyday God.

Songs of Hope

* * * * * * * *

Why do old, scratchy Vera Lynn records affect me the way they do? They leave me gasping, almost in tears.

The other night, when the announcer played "We'll meet again, don't know where, don't know when," he called it nostalgia. But the feeling that overwhelmed me was not any yearning for the good old days.

Because those weren't the good old days. Vera Lynn was singing about the war years. Friends said goodbye to each other in the morning, not knowing if both would return. Air raid sirens shrieked in the night, while people huddled underground in subway stations, feeling the earth shake around them. When they came up again, they frequently found their homes, their entire cities, in flames.

And it couldn't be nostalgia, because I don't remember Vera Lynn from those days. I was a child, too young to fight in that war, too young to remember much more than the hysteria of some adults.

So why should Vera Lynn's songs be special for me? After all, Glenn Miller had popular songs in those times too. But his songs can't compare. *American Patrol* tries to glorify war. *Kalamazoo* tries to ignore it.

Vera Lynn touches my heart because she did neither. Her songs recognized the suffering, the fear, the insecurity. But they reached beyond that to offer "love and laughter, and peace ever after..."

... and more than hope, of faith that this imperfect world can be reborn, that after the worst comes resurrection.

In the darkest days, she sang, "There'll be bluebirds over the white cliffs of Dover." No Easter hymn speaks any more deeply of human hope – and more than hope, of faith that this imperfect world can be reborn, that after the worst comes resurrection.

Faith. Hope. The overarching aspirations of humans that swell and grow, until they grow beyond self-seeking motives and personal gain.

It sounds religious. I guess it is. For I know other times when my breath has been taken away, when there's a lump in my throat and a warmth behind my eyes, when I feel at once humbled and exalted.

I don't know – perhaps I'll never know – whether the deepest yearnings of people down through the centuries make something holy, or whether they merely respond to something that's already holy. But I know that the two go together.

And so I find myself overcome by that sense of awe, that sense of being in the presence of the holy, when I step into the stained glass magnificence of a historic cathedral. Or when I escape from the roar of traffic, and discover a moss-grown spring deep in the woods.

It happens when massed choirs surge into the Hallelujah chorus.

And when a solitary whistler serenades a lakeside sunset.

It's there, in that sudden clutch of the heart, when your teenager graduates from high school, and when you discover a faded photo of your grandparent's wedding.

And so it's there, too, when Vera Lynn sings from the war years of courage and suffering, of loss, of faith and hope...for "tomorrow, when the world is free."

BIBLE READING

Moses and the burning bush ~ *Exodus 3:1–12*

Don't try to offer formal prayers.
Just sit for a while and remember those moments in your life when you were overwhelmed by something beyond yourself.
Maybe it was a place, a person, an event,
or all three.
Say thank you to God for them.

Communion Keeps Getting Better

● ● ● ● ● ● ● ● ● ● ● ● ● ● ● ● ● ● ● ●

My very first communion, I recall, was a disappointment. After all those years of waiting to be old enough to partake, the grape juice was warm and sweet, but the little cube of white bread was no more tasty than cotton wool.

Years later, I had similar troubles at my first Lutheran Eucharist, for a different reason. I was at Oberammergau, the little town in the Bavarian Alps where the village puts on its world-famous Passion play every tenth year.

In the evening, after the magnificent play, our group attended an ecumenical service in the stone sanctuary of the Evangelical Lutheran Church. It ended with communion.

I knelt at the altar and the priest gave me the wafer.

I slipped it between my lips. Instantly, the wafer glued itself to the roof of my mouth.

I'm afraid I took a larger sip of the wine, when the cup reached me, than I should have – I was so grateful to have something wet to soak that pesky wafer off my palate!

I have shared in communion in a college chapel, served by students. I've had it in an isolated Indian fishing village on Canada's west coast, and in a Newfoundland outport, where Atlantic surf smashed against the rocks only yards from the church's steps.

I've received communion in other countries. At an Anglican church in western Ireland, the pastor's accent was so thick it took me half the service to realize he was speak-

ing English. And in Copenhagen, where a huge domed church dwarfed the dozen or so worshippers.

The words were different; the Word was the same.

I remember especially communion in Africa. Black and white filled the pews of the Presbyterian Church in Blantyre, Malawi. They stood in the aisles, even clustered outside the doors. Some wore polished shoes, others had only bare feet. The singing, though magnificent, was all in the local dialect. I understood none of the hymns, none of the preaching.

Until the end of the service. When the minister stood, and raised the bread and broke it, I knew exactly what he was saying: "This is my body which was broken for you."

And when he held up the cup, I knew again what he was saying: "This cup is the new covenant in my blood. Drink this in remembrance of me."

Until then, I had been feeling lost, lonely, a stranger in an alien land. Suddenly, I realized that though I was halfway around the world from my home, I was at home.

I was among fellow Christians, and part of a universal family. The words were different; the Word was the same.

The significance of the Lord's Supper
~ *1 Corinthians 11:23–28*

*Remember some of the times and places where you have
had communion, and some of the people involved.*
Express thanks for those occasions.
Think ahead to the next time you will share communion.
*How can you affirm your relationships with others
around you?*
How about your relationship with Jesus?

The Feeling Something's Wrong

Strange creatures, we humans. We seem to have so much difficulty figuring out the right choices. But somehow, we know instinctively when something's wrong.

There's an old story about a person who was faced with a tough choice.

A friend offered an apparently flippant solution: "Toss a coin."

So the other did.

The friend asked, "How did you feel the instant you saw the choice that the coin had made for you?"

"Disappointed," came the reply.

"Then you know its choice was wrong," said the friend, "so disregard the coin, and do what's right."

C. S. Lewis, the author of *The Screwtape Letters* and the Narnia stories for children (and adults), once observed that we all have a strange feeling occasionally of being aliens in a world that has gotten out of joint. Something tells us we were meant for something better than wars, or selfishness, or broken marriages.

Sometimes it takes time for that realization to get through to us.

You don't imagine, of course, that a casual flirtation could eventually lead to a messy divorce. It seemed harmless at the time.

You don't realize that a business sale to a foreign investor, or a large bank loan to an international corporation,

... that sudden sense of alienation from the world around you is evidence there is a God.

might ultimately contribute to a branch-plant economy and to a loss of your own economic autonomy. It seemed good business at the time.

Wrong decisions like these rarely show up as quickly as a flip of a coin. But in the end, they always surface – when you find your associates aren't the kind of people you would choose as friends, when you see your bad habits copied by your children, when national economic trends turn towards disaster, or perhaps when your life seems to be pointed downwards more and more steeply.

What is it that tells us something's wrong? C. S. Lewis says it's God.

Or to put it another way, that sudden sense of alienation from the world around you is evidence there is a God.

We all have that feeling sometimes. Even atheists, who believe so strongly in not believing that they spend their lives trying to prove there is no God, have it.

If there really weren't a God, you would never know you had made a wrong choice. Because if you're the final judge yourself, any choice you made would have to be right, wouldn't it?

BIBLE READING

The temptations of Jesus ~ *Matthew 4:1–11*

It may seem like a contradiction, but say thank you to God for the times when you know you've made a mistake, because recognizing that it was wrong shows you that there was a right choice.
Ask for support and partnership in the future, so you are not alone when decisions have to be made.

The Parable of the Pigs

• • • • • • • • • • • •

A couple of summers ago, my family visited a reconstructed farm where things were done in the old ways. We saw plows pulled by horses, and cows being milked by hand.

And the pigs weren't in one of those modern antiseptic pork factories, all stainless steel and scrubbed concrete. They were in a barn with a dirt floor. They could run free outside, in a yard with two big gooey mud wallows in it.

My daughter watched the young pigs dive into the wallows. When they scrambled back out of the mud, they were sticky, black, and glistening.

She saw that there were some little pigs that didn't pitch themselves into the mud. Their hair was white, their skin pink and gleaming. They stayed clean – for a while.

But as they bounced and tussled in their play, as they pushed and shoved together to get their share of milk from their mother, some of the grime on the dirty pigs rubbed off on the clean ones.

It wasn't long before they were all filthy.

"Yea-uck," said my daughter, making a face. "How can they stand being so dirty?"

It didn't occur to her that those pigs could be a parable. Like the stories Jesus told which seemed to be just about sheep or seeds, there's a hidden message in their grime.

You see, at that time, she was hanging around with a bunch of kids who were experimenting with trouble. She could tell herself that she was different. She could believe that being with kids who'll try anything for kicks was just harmless entertainment. And she might indeed be harder working, more thoughtful, more honest, more Christian than them.

They're not all that way. Maybe only very few are. But people lump the good in with the bad.

But just like the pigs, some of their "dirt" would stick to her.

Other people won't make allowances for how much dirt there is on her, compared to others. Or how it got there. Rather, the same way that she wrinkled her nose in distaste over all the pigs, they're going to lump her together with the worst of her companions.

It's wrong. It's unfair.

But it happens.

That's why immigrants get labeled as lazy, or dirty, or smelly. And why politicians are seen as shifty, union leaders as leftist subversives, businessmen as hard-hearted exploiters, and Christians as pie-in-the-sky fanatics or self-righteous hypocrites.

They're not all that way. Maybe only very few are. But people lump the good in with the bad.

To avoid that stereotyping calls for an exceptional effort

– from a teenager, or from an immigrant, a politician, a union leader, a businessman, a Christian.

Or for a different choice of associates.

Pigs don't have choices like that. People do. That's what God was pointing out, to both my daughter and me, in the parable of the pigs.

Too bad we drift into friendships and actions more often than we exercise the privilege of making those choices.

The choice between good and evil
~ *Deuteronomy 30:15–20*

Discuss, with God, a few of your friendships.
Are there some that you're ashamed of – because you've chosen them for your status, or your pleasure?
Which friendships give you a warm feeling?
Is it because of what you've been able to contribute to the relationship? Or because you can depend on your friends' acceptance of you?
With God as witness to your decision, resolve to value friendships more, to put some commitment into them.
Choose life; don't simply drift.

For the Good Years

· · · · · · · · · · ·

Marion lay in a hospital bed. She seemed to have shriveled; the sparkle that had gained her so many friends over so many years had almost gone.

A week before, she had her second operation for cancer. Her doctor didn't want to do it. He said she had no chance. It was only a matter of time.

But she had a tremendous will to live. Not so much for herself. But for her brother, a wisp of a man, who had no other family left. And for her friends, with whom she had shared so much of herself over so many years.

She needed all of that will to live. Within the next week, she had to have two more operations, one of them an emergency. Her doctor was away with his family, celebrating a holiday, when he had to be called back to the hospital, flown back on a specially chartered plane, to save her.

Now she's sewn up across her stomach, and up her chest, and around her neck. Her voice has gone forever. She writes notes to her brother, on a little slate, when she has the strength to raise her hand.

Sometimes she can't see what she has written, for the tears of pain that mist her eyes.

Sometimes her writing gets so shaky – when her o's have corners – that her brother has to guess what she's saying. But always she wants to know, "And how are you?"

There's not much you can give a person trembling at the edge of death's cliff.

Just before the last emergency operation, needed to stop the internal bleeding that was pumping precious blood into her stomach, she still thought first of others. She wanted to send a small gift to a friend. She asked her brother if he could deliver it for her.

It almost broke his heart. The person who most needed a gift, he thought, even just a day without pain, was his sister.

There's not much you can give a person trembling at the edge of death's cliff.

But he found something. Something she would like.

Years before, she had written an article about her beloved collection of bells. Little bells. Bells of many shapes and sounds, each one with its own significance, its own meaning.

But during the last years, those bells disappeared. No one knew where, or how, or why.

So her brother took time away from her bedside, to go back to the family home where she used to live. In the debris still haunting the corners of the attic and the storage cupboards, he found one bell. One small silver bell.

He took it down to the hospital. And as she lay with the blood transfusion dripping into one arm, the intravenous tubes dripping into the other, her hands too weak to write, her eyes blurred from the ache of three major operations in one week, he took the little silver bell from his pocket.

Gently, with just the tips of his fingers, he rang it.
For all the good years.

BIBLE READING

A sick man's lament ~ *Job 6:8–14a*

*Share with God a few of the moments when you have
been hurting and in pain.*
During illness. During grief. During loss or rejection.
*Also share some of the ways that people let you know
they cared.*
A note. A gift. A tear.
*Remember those who could use some sign right now that
you care.*
*Confess what you haven't done for them, or haven't done
enough of.*
Resolve to do some of those things without delay.

The Universal Rock

● ● ● ● ● ● ● ● ● ●

I was looking for the United Nations in New York.

I knew where to find the buildings. They rise from a 16-acre site on the East River, between 42nd and 48th Streets, in an area that used to be rundown industries and slaughterhouses. But I was looking for more than a physical location.

I wanted to find that indefinable "something" – whatever it was – that made the uniting of nations important.

As I walked down the streets toward the East River, the four connected buildings of the U.N., topped by the Secretariat's 39 stories of green-tinted glass, were framed between New York's grubby commercial buildings. Taxis blared and clattered past; pedestrians casually added their contributions to the litter cluttering the gutters.

But that wasn't the United Nations I sought.

I strolled through the gardens, where plants from around the world thrive in tons of imported topsoil. Myrtle and wisteria lined the walks; hawthorns, sweet gums, pin oaks and flowering fruit trees rose above the roses, the English ivy, the manicured grass. But they weren't that "something" either.

I wandered wherever I could through the buildings. My footsteps echoed down terrazzo corridors and padded through vast carpeted council chambers. In the three-story hall where the General Assembly meets with

its 2,100 seats for delegates from 150 countries, I sensed the sound and fury of international politics wash over me – but that wasn't what I was seeking either.

Just a lump of rock and a quiet room.

I ended up back in the hurly-burly of the main concourse. And there, where busloads of school children on educational tours mingled with plodding tourists burdened by cameras, all hustling to buy international souvenirs, I found what I was looking for.

Off to one side, a small room rested still and dim. Inside, the light from a single light sifted down over a massive lump of iron ore, softening its harsh edges in shadow. Peace settled on visitors like the touch of a gentle hand. Even tourists, who entered clamoring through their guidebooks, emerged hushed.

It's called the Meditation Room, but I think of it as a chapel for people of all faiths. It's not just for Christians – it has no crosses or Bibles. Nor is it Jewish, Buddhist, Moslem, or Hindu.

Just a lump of rock and a quiet room.

There, serenity can blunt the barbs and darts of life. And as we peel away the layers of the everyday, we can all realize that whatever our religion, whatever our expectations of future life, all our present lives are lived here on this chunk of rock in the universal silence of space, on our planet Earth.

BIBLE READING

The Lord of the whole earth
Psalm 95:1–7

Express gratitude to God for this world, in which we are
able to live.
For its beauty. And for its fragility.
Consider how easily the foolish acts of humans could
turn it into a lifeless cinder in the emptiness of space,
rather than the garden planet we now share.

Too Much for Mere Mortals

● ● ● ● ● ● ● ● ● ● ● ● ● ● ● ● ●

When I was young, I read Kenneth Grahame's *The Wind in the Willows.*

At that time, with the highway of life just opening before me, it was a hilarious tale of high adventure, of Mole and Rat and Badger, but above all of irrepressible Toad of Toad Hall.

Not long ago, I read *The Wind in the Willows* again. But I'm older now. And I've discovered that life's highway has many potholes and detours. This time, a forgotten chapter burst from the book with a brand new message for me.

In the chapter called "The Piper at the Gates," Mole and Rat go searching for a lost Otter child. During that still hush just before dawn, they are led by strange liquid music to an island. There, they find the lost Otter child, lying at the feet of a magnificent being, the great god Pan of the animal kingdom.

Author Grahame writes:

> Then suddenly the Mole felt a great Awe fall upon him, an awe that turned his muscles to water, bowed his head, and rooted his feet to the ground.
>
> "Rat!" He found breath to whisper, "Are you afraid?"
>
> "Afraid?" murmured the Rat, his eyes shining. "Of him? Oh never! And yet – and yet – O, Mole, I am afraid!"

... the gift of forgetfulness lest the awful remembrance should remain and grow, ...

Sudden and magnificent, the sun's broad golden disc showed itself over the horizon; the first rays took the animals full in the eyes and dazzled them. When they were able to look once more, the Vision had vanished, and the air was full of the carol of birds that hailed the dawn.

The moment of enchantment, when Mole and Rat knew they were in the presence of God – their god – had passed. They shook their heads, knowing something special, something extraordinary, had happened. But they were no longer quite sure what. Already the memory was fading.

Grahame explains why: "For this is the last best gift that the kindly demi-god is careful to bestow: the gift of forgetfulness lest the awful remembrance should remain and grow, and the great haunting memory should over-shadow all the afterlives of little animals..."

How often we mortals lament that God is not imme-diately evident in our disordered world! But that's as it should be, Kenneth Grahame tells me in the pages of a children's book. I am but a human – to live daily with the full glory of God would be too much for me.

But as the Rat said, "And yet – and yet..." We have all, sometime, stepped across an unseen threshold into the Holy, when time for an instant stood still. A moment of overwhelming beauty, or joy, or sorrow, or love. In that moment, each one of us has met God.

But to live for long in that exalted state would surely destroy us. So a merciful God allows the memory to fade. We can forget. We can be human again.

BIBLE READING

Moses wanting to see God's face ~ *Exodus 33:15–23*

Say thank you to God for the times when God's presence has broken through to you.

Admit that you have sometimes resented that those high moments faded, and you found yourself in the humdrum daily routine again.

Apologize for that resentment, and express gratitude that they have provided glimpses of what can be, without destroying what presently is.

God Doesn't Compete
• • • • • • • • • • •

Small country churches are the poor relatives, the nobodies, in most religious denominations these days. They're pitied by their larger and more affluent city cousins.

The big congregations, with fancy choirs, carpeted meeting rooms, and elaborate Christian education facilities, are in the cities. That's where the best preachers usually wind up, and the best teachers, and the best counselors.

With all that talent and money available, city churches ought to be doing a better job of religion than the country churches. But they aren't.

There are many excuses for their failures. Excuses such as apartment living, which discourages any sense of permanence. Or business concerns, loneliness, and alienation. Or the amount of time people have to spend commuting...

The fact remains that the larger a city becomes, the smaller the proportion of its people who belong to church, who find God important in their lives. And, strange as it may seem, most of the ministers of these large city churches had a rural upbringing. For years, the Atlantic provinces supplied ministers to the rest of the country, far out of proportion to their populations.

The late William Cameron was minister of the largest Baptist church in Canada, Yorkminster Park, in Toronto. He was a farm boy from Palmyra, in southwestern Ontario.

Once, when asked why so many ministers came from farm backgrounds, he replied, "It was because God had a better chance to get at us there than in the city."

With that, he put his finger squarely on the problem of the city. It's the city itself. The bigger the city, the more things going on. Whether you take part in them or not, even if you aren't consciously aware of all the things that are happening, there's a hustle, a bustle, that demands your time and energy. God simply becomes one more element competing for your attention.

Except that God doesn't compete. Not the way television does, or the traffic, or the need to drive your children to their gymnastics classes or music lessons.

Jesus knew that. He spent a lot of time in crowds and in cities. In the gospels, "multitudes" are mentioned 71 times, I'm told.

But just as often, you read of Jesus getting away from the multitudes – going off alone into the desert, into the mountains, in a boat, into the garden of Gethsemane. He knew that God won't compete for attention.

The same with us. We are less likely to hear God in the tumult of traffic, the clamor of children, the swirl of schedules.

Only rarely does God break through the pressures of our daily lives and demand our attention.

Rather, God expects us to pay attention.

Only rarely does God break through the pressures of our daily lives and demand our attention. Rather, God expects us to pay attention.

The monks and hermits of bygone days, who withdrew to solitude to contemplate God, may have been wiser than we give them credit for being.

For the doing of God's will may be in the crowded walks of life. But the hearing has to be in reflection and solitude.

BIBLE READING

The Garden of Gethsemane ~ *Luke 22:39–46*

Think about the times when you feel you have to get away by yourself.

Describe some of the pressures you've been living with the last while and how they have kept you from paying attention to God.

Thank God for being willing to wait, for being there at the times when you do manage to break away.

Work It Out Yourself!

• • • • • • • • • • • •

A friend and I were trying to solve a small engineering problem. For his business, he needed a fairly simple mathematical formula that he could use to save himself from going through hours of trial and error calculations every time a particular problem came up.

It really wasn't a difficult problem, in retrospect. A graduate engineer might well have been able to give us the formula, right off the top of his head. A skilled mathematician might have worked it out for us in a few minutes.

But we had to start from the beginning, working our way through from basic principles and practical experience.

So the two of us spent a whole evening, batting ideas back and forth, struggling with trigonometry and algebra and binomial equations.

Eventually we got the formula we needed. When we had it all laid out on paper so that we could understand it, we had gone through 27 steps, from original problem to final formula.

Later, we looked again at those 27 steps. We discovered we didn't need that many. Now that we knew what we were doing, the process could be cut to just three simple, straightforward steps!

When I think back to that struggle, it seems very like the way I learned about God. I started from our everyday

But we had to start from the beginning, working our way through from basic principles and practical experience.

*But as we keep
finding, God is
much more than
any equation ...*

experiences. I chased up blind alleys. I missed obvious answers. I discussed my misunderstandings with other searchers, as if all the floundering were really leading me towards the truth.

Didn't you do the same?

But once we do discover God – God who has been there all the time, waiting for us – we look back and see how simple, how straightforward, the whole search could have been.

That's when we create trouble for ourselves, and for others. We start to think that we can save other people so much time, so much effort – if they would just follow our route to God.

That might be true if God could be reduced to a formula.

But as we keep finding, God is much more than any equation – whether of figures, symbols, rituals, or words.

That is why each person has to go through the struggle of discovery. Each person has to launch that individual search, and make mistakes, and get lost, and eventually discover just how simple it all could have been.

And once your discovery has been made, all you can do for other people is to encourage them to keep on searching.

Even though it would be a lot simpler, you just can't make their discovery for them.

B I B L E R E A D I N G

Towards fuller understanding
~ *1 Corinthians 15:11–12 and 2 Peter 5:14–15*

Share with God some of the painful steps your faith has gone through and is still going through.
Express thanks that you were given time to grow.
Acknowledge that your faith is not yet perfect, but has more growing to do.
Ask God to have patience.

The Testing of Fred's Faith

Sometimes you never know for sure what you believe, until your beliefs come under fire. Fortunately for most of us, our faith isn't tested the way Fred Morris's was.

Fred was a U.S. Methodist minister, a missionary in northeastern Brazil. In 1973, I lived with Fred for a few days. He introduced me to Archbishop Helder Camara, world-renowned for his work with the poor and oppressed. Fred drove me through the luxury suburbs and the downtown high-rises. And he took me into the slums, into the squalid, stinking riverbank villages where some of the people he worked with lived in shacks built on spindly stilts over the mud and sewer sludge. Each day, when the tide went out, they groped in that stinking sludge for a few polluted crabs to eat.

Recife, his city, was a revolution waiting for its chance to happen. The whole area, where Brazil bulges far out into the Atlantic, was desperately poor. Almost 30 percent of the people were unemployed; most of the rest were underpaid.

The land was fertile. That area could have grown enough vegetables and grain to feed almost the entire country. But Brazil's "economic miracle" called for industrial development and export dollars. So some farmland was used for automated factories that threw more people out of work. And the rest grew sugar for export. As a result, fertile northeastern Brazil became the only

part of the Western Hemisphere to experience starvation regularly.

Fred Morris used to get very angry about what was happening to ordinary people. Once in a while, he got angry enough to write an article for U.S. magazines, about what he called "The Other Side of the Economic Miracle." About peasant farmers, machine-gunned because they had tried to keep a small plot of land as a vegetable garden for their own families. About Brazilian church leaders who dared criticize their government, and who were repaid for their courage by being shot, hung from trees, dragged behind cars, and tortured.

And then one day the police came for Fred. About a dozen of them, he said later. With machine guns. He knew they were police. He had met some of them before.

They took him to a building where he knew others had been tortured. And he was very afraid. For four days, they tortured him. They clipped electrodes to his toes, his fingers, his nipples, his ears. Then they turned on the current, and laughed at him as the white-yellow explosions went off inside his skull. They mocked him in other ways. They called him a Communist and a traitor. They told him they had taken his wife and son, too.

Fred turned to his Christian faith for strength. "I repeated the 23rd Psalm, every time they came for me," he

And then one day the police came for Fred.

He realized that nothing, not even torture, could separate him from the love of God.

said. "Though I walk through the valley of the shadow of death, I will fear no evil…"

And he got an unexpected lift from one of his torturers. The man jeered: "All your friends are over at the church, praying for you!"

It was supposed to convince Fred that prayer was useless.

But the ploy backfired. Just knowing that his friends would risk their own safety by praying for him, publicly, was enough for Fred.

And in the middle of his terrible experience, under torture, Fred discovered something about himself. "All the things I had been saying I believed for the past 20 years were true," he said later. "I wasn't just saying those things. I really believed them!"

He realized that nothing, not even torture, could separate him from the love of God.

He found that he could not hate his torturers, in spite of what they were doing to him. "I felt sorry for them. They degraded themselves more than they degraded me."

And he said, "There was a time, during those four days, when I really thought I was going to die – and I was able to face that without fear."

He didn't die, of course. Because Fred Morris had the advantage of being an American citizen, his friends could

contact the American Embassy and get him released. Brazilians aren't that lucky.

Fred eventually left Brazil. But in a strange way, he told an interviewer months later, he found himself almost grateful to his captors. Because, like everyone else, Fred Morris used to have some doubts about what, and how much, he really believed. But now he has been tested. Now he knows for sure.

BIBLE READING

Faith refined by fire ~ *1 Peter 1:3–7*

Recall a person, a parent, a lifelong friend, in whom you always had a "tender trust."
You always knew they loved you, no matter what.
Tell God about that person.
Thank God for being someone else in whom you can always trust.
Look back on a few of your bad times, and how your "tender trust" in God survived those times.

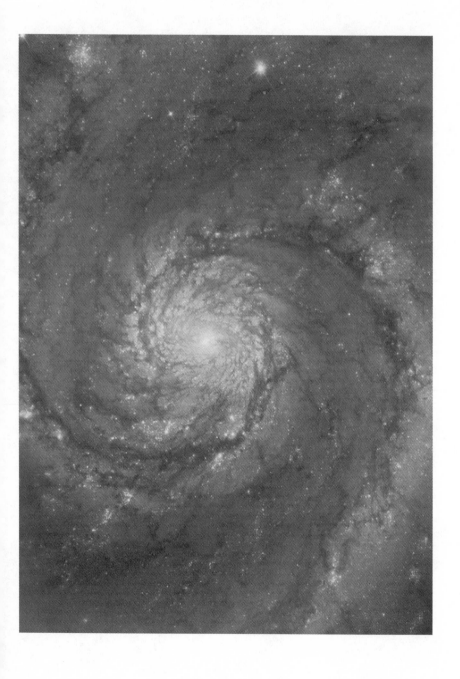

3 · · · SEEING
THE WHOLE STORY

How to read the right script

If you want to understand the plot and characters of a book – any book – you have to start at the beginning. You have to read the opening chapters.

In the Christian story, those opening chapters are the Bible. That story is still going on, and we are part of it. We add pages every day, by our actions and reactions.

But in the deluge of conflicting messages dumped on us each day, how do we sort out which ones are God's? The only way is to know those opening chapters thoroughly. So that we can play our parts with confidence, sure that our scenes are consistent with the record of the prophets, the life of Jesus, and the letters and doctrines of the Christian church.

Not necessarily identical. But consistent.

Two centuries ago, many scientists thought that the earth had been shaped by forces that no longer existed. A Scottish country doctor named James Hutton saw what wind and waves, erosion and silting, were doing right then. He became known as the founder of modern geology for insisting that any forces which had shaped the earth in the past were the same forces observable today.

Christians could learn from that principle. The past and the present tell the same story. Today's experiences and the Bible are not separate, but linked. And continuing. And meaningful.

Tuppence, My Arthritic Cat

• • • • • • • • • • • • • • • •

My cat Tuppence, now 12, can't jump as high as she used to. When the weather grows cold and wet, she gets twinges of arthritis, we suspect.

... it occurred to me that I had just acted out a Bible story.

But she still likes to get up into the bathroom window – the highest point in the house – where she can peer out and survey her front yard. The other morning, while I was shaving those parts of my face that still recognize a razor, Tuppence stood by my feet and yowled at me.

I wiped the clutter to the back of the counter, so that she could jump up onto it safely, and from there to the window.

Still she yowled.

"Go ahead and jump!" I spluttered through the lather. "It's clear."

"Meeiiaaaooooww!" she replied.

"Quit complaining and jump," I told her. "You know you can do it."

"...yiaaaoooww..."

"Look cat, I've got things of my own to do. I am not going to lift you!"

"...aoooww..."

In the end, of course, I gave up. I scooped her up and placed her safely over my head in the window.

"Merp!" she said, in what I assume was meant to be thank you. As I stood there, dripping lather, it occurred to me that I had just acted out a Bible story.

Because that incident with Tuppence was almost a replica of several stories that Jesus told. He talked about people knocking on doors in the middle of the night, until finally the frustrated owner opened up and offered help. He told about a woman who pestered a judge until she got a fair hearing. And though they didn't want to, the people hiding behind their locked doors or their authority eventually gave up trying to ignore the interruptions, and yielded, and did what they should. Just the way I eventually yielded and lifted my cat.

Each story is true – in its own time. Yet you would have trouble if you took the story about pestering the judge too literally today. If you were to try doing that today, you'd get contempt of court, very quickly. Yet it was true then, if you read it in its own social and cultural context.

If every word in the Bible were divinely dictated, then a truth about persistence in knocking on doors would not hold for ringing doorbells (which didn't exist in those days). Or for presenting a brief to government. Or organizing public opinion to get unjust laws changed. Only for knocking on doors.

The Bible was written by people who knew nothing but donkeys, scrolls, and oil lamps. But I don't want to see the Bible limited to that kind of world. We live today among jet planes, instant electronic communication, and international energy crises. And try as I will, I cannot

believe that people writing about donkeys really meant jet planes, or that oil lamps are another way of referring to fossil fuel shortages.

But I can see the truth of the Bible still going on all around me.

But I can see the truth of the Bible still going on all around me.

Maybe not exactly the same – we're dealing with nuclear bombs now, not swords. But the truth that keeps bursting forth – when a yowling cat, for example, reinforces a biblical message about persistence being repaid – reassures me that my religious life is not limited to donkeys and oil lamps. What I do about nuclear weapons, about social justice, about human rights, about anything that makes up this modern world, is part of my response to God.

And if I wait, and watch, sooner or later God will speak to me through this world.

Even if it comes through something as mundane as an arthritic cat.

BIBLE READING

The midnight door knocker ~ *Luke 11:5–13*

Tell God about the events of the past day.
Don't worry about whether they're special or not – just
share them.
Mention especially any acts of kindness or thoughtful-
ness you noticed.
Maybe they happened to you, or to someone else.
Or you heard about them on the radio, in the papers, or
on television.
Say a word of thanks for those acts, on behalf of those
who may not realize what was done for them.
And say thank you to God for being "like that, only
more so."

Looking for the Perfect Gift

In my family – maybe in yours too – choosing the right gift for the right person always causes trouble.

We have difficulty with the smaller gifts, the ones we give our distant relatives, the aunts and cousins we may not see again in our lifetimes.

One Christmas, we decided to give them all candles. "This one is just the right color for Susan," Joan said.

"But it's too pudgy," I countered. "She could think we chose it because it's shaped like her."

So you can imagine what it's like trying to choose gifts for our parents and our children. It takes months of talking – and eventually of avoiding talking – about what to buy.

After a while, we may even start resenting them because of the difficulties they cause us. Instead of peace and harmony, we build up friction.

Which is silly – because God gave us a very different example at the first Christmas.

God didn't ask the world for lists of what we would like. God didn't fuss about whether this gift was going to be practical.

God gave us, in the traditional words, "his only begotten son," Jesus of Nazareth. Without any fancy wrappings: just a manger, in a stable. A squalling, howling baby. Another mouth to feed in a country occupied by enemy troops.

... because God gave us a very different example at the first Christmas.

Jesus wasn't "just what they had been wanting." He came as quite a shock to many people, so much that they eventually crucified him. And still today, he causes rifts among people all over the world.

Yet Jesus was, and still is, the ultimate Christmas present. No other gift has matched that one, and none ever will. Because unlike us, who fuss and dither about gifts, God knew exactly what to give the world, and gave it.

BIBLE READING

The greatest gift ~ *John 3:16–17*

Why do you give gifts?
Because you're expected to? Because you expect something in return?
Do you act on impulse, because something makes you think of the other person? Or do you make detailed lists, and balance the value of the gift against the closeness of the relationship?
Do you think God used any of those criteria?
What kind of gift would God like to receive from you?

Pass It On

● ● ● ● ● ●

I read a story, years ago, about a man whose car ran out of gas. A passing motorist stopped, dug a battered red can of gas out of his trunk, and gave it to the author, without charge. The only condition was that he had to pass it on, in turn, to someone else who needed it.

Good fortune must be shared, not hoarded. The can must be passed on.

So the writer of the story did. With the same condition.

Good fortune must be shared, not hoarded. The can must be passed on.

Of course, years later, the same motorist ran out of gas again. And, of course, another one came to his aid. And to his amazement, he was given back the same old gas can, considerably more battered by now, but undeniably the same can.

More recently, I saw a similar kind of story in a church magazine. When the author went to his car in the parking lot, he found that his gas tank cap was missing. His first thought was that someone had swiped it. So he bought himself a locking gas cap. "That'll fix them!" he thought.

But later, he began thinking about two kinds of worlds – the kind where you had to keep everything under lock and key, and the kind where everyone was willing to share. Wouldn't it be much better, he thought, if he saw someone without a gas cap, to share whatever he had, even his only gas cap – knowing that someone else would do the same for him?

That's the kind of world Jesus was talking about, when he gave his disciples the great commandment. "Love others, as I have loved you," he said.

"Pass it on," he was saying. "Don't try to hoard the good things. They're not yours to keep."

That applies to our time as well as our possessions. Sometimes my wife, Joan, asks me why I let people take advantage of me. Some of them may never repay me.

I can't answer her question. All I can reply is that I don't really have a choice. All through my life, people have done me good turns. Sometimes I haven't realized at the time that they were doing it. Sometimes, perhaps, they themselves may not have realized what they were doing for me. But I've ended up with the benefit.

I can't pay them back. I don't know who some of them were. Others are long out of touch. Some have already died.

So I have to do the next best thing. I have to pass it on.

Someday, like the gas can, some good that I have done for somebody may come back to me. But if it doesn't – well, all that really matters is that they "pass it on," too.

Love for enemies ~ *Luke 6:27–36*

*Acknowledge times when you have felt bitter or hurt
because people whom you had helped took it for granted,
with not even a word of thanks.
Confess that you haven't always repaid your obligations
for others' kindness.
Sometimes it was too late to do anything.
And what about repaying God's goodness to you?
Express gratitude for the opportunity of passing it on to
others.*

A Psalm for a Storm

· · · · · · · · · · ·

I should have felt weak, powerless, and helpless. And I did. I should also have felt terrified. But I didn't.

When I lived on the west coast, I enjoyed going down to the ocean shore, in a storm. A thousand miles of waves came crashing at my feet. The wind caught the salt spray and whipped it against my cheeks; the combers churned up the beach, smashing themselves into nothingness, making the very earth tremble.

And you know, as you stand there, that if you slip, if you fall, you could no more survive in that fury of water than can the fragments of seaweed, ripped from their growing places, pulped and shattered and eventually spewed up along the beach. Even the beach itself is a product of the ocean's rage. Those grains of sand, those pebbles, were broken and rounded by the surf hurling one rock against another, over centuries of temper tantrums.

When the roar of the breakers surrounded me, like solid sound, I should have felt weak, powerless, and helpless. And I did.

I should also have felt terrified. But I didn't.

I was exuberant, exultant. At the top of my lungs, I sang snatches of songs, shouting words that were whipped out of my mouth by the wind before I could hear them myself.

It used to puzzle me – whenever I bothered thinking about it – the way the psalmists mixed humility and rejoicing. David wrote humility into what we call Psalm 8: "What is man, that thou art mindful of him…" But in the

rest of that psalm, I can almost hear David whooping into the wind, "Hooray for God!"

Humility, insignificance – we humans try to avoid thinking about such things. As one of my former ministers once remarked, "Humility is not a virtue you can be proud of!"

But standing there on the beach, the gale plucking at my clothes, I knew he was wrong. You can be both humble and exultant at the same time.

For I was not just a victim cowering before the storm. I was also victor over it.

Behind me on the bluffs, overlooking the beach, stood a community of homes. In houses of hewn stone and sawn timber, people lived, safe from the storm. The riches of the earth kept us all warm and fed. Indeed, in that sense, God had given us "dominion over the works of God's hands," and had set us only a little lower than the angels.

But the waves, their majestic rhythm crashing at my feet, made clear to me my own weaknesses. The home, the food, the comfort, and the power I had available were not merely my own doing.

So they could only be God's doing.

"O Lord, Our Lord. How excellent is your name in all the earth."

BIBLE READING

God's glory, humans' dignity ~ *Psalm 8*

Don't say anything. Just listen.
Listen to the sounds of life around you, and within you.
Listen to the "music of the spheres," and let it flow into
you and around you, the way warmth does when you
hold the hand of someone you love.
Simply soak up the glory of God for a while.

The Power of Positive Toothaches

My dentist says that I'm the only person he ever heard of who managed to have a psychosomatic toothache.

The pain in my tooth was agonizing, but neither his X-rays nor his drills could find anything wrong with it. Eventually, when I stopped being upset about a particular personal situation, when I got rid of the anger and bitterness, that toothache went away.

"If you can think yourself sick, you can think yourself well. There's a moral for you. Think well!"

I remembered my toothache recently when an unusually large number of prominent people and business associates suddenly had heart attacks.

One of the secretaries in my office remarked – with what was supposed to be reassurance, I think – "Well, at least you'll never have a heart attack. You never take anything seriously!"

That's when I remembered the toothache. And a backache, one previous time. And the pulled muscle just before the high school high jumping finals...

"Think about it this way," she comforted me. "If you can think yourself sick, you can think yourself well. There's a moral for you. Think well!"

She was telling me, in modern language, the very same thing that Jesus tried to tell us 20 centuries ago.

The Pharisees were arguing that what makes you sick is what goes into you. Two thousand years ago, they took the approach that has been most common in medical practice through the centuries – sickness is caused by external

*... but think good.
Think kind.
Think forgiving.
Think love.*

factors. So they had strict regulations about what they ate, and did, and whom they associated with.

And if you think about it, we still endorse the same concept. We blame illness on germs that come to us from outside. So we wash our hands and avoid people with contagious illnesses. We switch from one nutritional food to another, and try to buy health in packages, egged on by the pressures of mass media advertising.

But Jesus was more perceptive. Like an increasing number of doctors and psychologists today, he said that we create our own well-being, or lack of it. "From within, from the heart of humans, come evil thoughts, fornication, theft, murder, adultery, coveting, slander, pride, and foolishness. All these and more evil things come from within, and they defile a person" (Mark 7:21–23).

Jesus made it all too clear. Your thoughts determine what kind of a person you will be, far more than what you eat, or the rules you obey, or the rituals you follow.

So think well. Pardon my grammar, but think good. Think kind. Think forgiving.

Think love.

Maybe there's a lot more significance than we normally realize in a minor change that Jesus made in an Old Testament commandment. In Deuteronomy, the Bible says, "Love the Lord your God with all your heart, and with all your soul, and with all your might" (Deuteronomy 6:5).

According to Matthew's report, Jesus changed that last word ""might," into "mind" (Matthew 22:37).

You can't do it yourself. But if you start, as the commandment says, by loving God, maybe you can truly think well.

BIBLE READING

The causes of uncleanness ~ *Mark 7:14–23*

Tell God, as a friend whom you can trust not to gossip with anyone else, about some of the things that are hurting you right now.
The people who have done things that you feel you can't forgive.
Your fears about the future.
Your anger about the past.
Explain to God how you feel about these things, how they churn you up inside.
Then thank God for listening, and for sharing the burden with you now, so that you have only part of the load to carry.

Walking Wealth that Jingle-jangles

● ● ● ● ● ● ● ● ● ● ● ● ● ● ● ● ● ● ●

In India, that land of universal poverty, where I spent my earliest years, one of the universal sounds was the clink of gold and silver.

It comes from bracelets worn by the women. Even the poorest women will wear a few bracelets. And as they sway down the paths worn hard and smooth by bare feet, carrying an earthen pitcher of water on their heads, as they sweep up a few kernels of grain from the earth by their houses, their bracelets ring a tinkling music.

Some women wear only a couple of copper or bronze bands around their wrists. Others have bracelets of gold and silver mounded from their wrists up their forearms, and massed anklets riding up their calves. They had, in the words of the old nursery rhyme, "rings on their fingers and bells on their toes." Literally.

I remember asking my father, a missionary, why they did it.

"That's the family's entire wealth," he explained. Husbands converted their earnings into precious metals. Then a local goldsmith or silversmith formed a bracelet around the wife's wrist, or her ankle.

I thought that was silly. Even as a six-year-old, I knew enough to put my allowance into a savings account.

But my father replied: "The people don't trust the banks and the moneylenders. They say that anyone can rob a bank, but the only way to steal from a wife is to cut off

her arm. And a banker who gets robbed may try to keep it quiet so that people won't lose confidence in his bank – but a wife being robbed will always scream for help!"

Nowadays, I have second thoughts about different systems of handling wealth.

I see Western investors sinking their money into gold, like the husband.

I see inflation shrinking my treasured savings account. And the up-and-down values of the shares in my retirement plan reflect the misfortunes of business.

All around me, I see people pouring their earnings into cars, which they flaunt until the metal rusts away. They buy cottages, snowmobiles, boats, and skis – and then feel compelled to make use of those investments every minute of their "spare" time.

And I wonder if our system of handling wealth is really any better than the Indian one.

Still, I'm not likely to start loading my wife with bracelets.

Because I remember an Indian woman. Business went well for her husband. Soon she carried such a load of gold and silver, she became quite useless to him. She could no longer cook, or sweep, or tend her animals or her children.

She could barely move for the weight of her wealth.

As the Bible asks, what benefit is there in possessing the

She could barely move for the weight of her wealth.

whole world, while losing the value of your own life?

We North Americans, as a whole, are the wealthiest people in the world. We ought to learn something from that Indian woman about the burden of trying to have more than enough.

B I B L E R E A D I N G

The things that are worthwhile ~ *Matthew 16:24–28*

List in your mind some of the things that you have but don't use very often.
Tell God how you feel about these things.
Do you feel pushed to use them because of the money you've spent?
Have you ever offered them to someone else to use?
Now name the things that you would like to get, or plan to spend money on.
Then stop talking and listen. Hear what comes back to you.
About why you want these things. About their effect on your life. About who they're going to help.
Ask God to be with you, and to give you good advice, when the time comes to spend your money.

Following the Right Road

.

I could never be an atheist. I don't have enough courage.

I realized that while thinking about a couple of incidents – both having to do with driving a car, as it turns out.

In the first incident, my son and I were off to a Scout camp. He wanted to know what highway we turned at.

"It's on the way to Alliston," I said. "I think it might be Highway 88."

Suddenly, as we drove along, he pounded me on the shoulder. "You have to turn off here!" he told me. "This is number 88!"

"It's the wrong road," I said, and kept going.

"But you told me number 88," he insisted, quite distressed.

"It's okay," I reassured him. "I know the road."

Sure enough, the right road came up a couple of miles later, and we arrived at our destination.

The second incident was something similar except that I didn't know the road personally. I was following a friend's directions. Our family was enjoying the drive, noticing the landmarks the friend had told us to watch for as we went along, confident that we were headed in the right direction.

Then something went wrong. Maybe we failed to notice a sign, or turned left instead of right – I don't know what it was. But all at once, the country wasn't as friendly as it had been. Nothing was familiar or dependable anymore.

Everything was strange. It was a different world, and we were lost in it.

It occurred to me that both incidents were like a parable. Many people find themselves lost in a strange world. So they race down one turning or another, hoping it will bring them back to familiar ground. Sometimes, like my son and the highway number, they seize part of the answer as if it were the truth, the whole truth, and nothing but the truth. They gamble all their faith on astrology, magic, sex, meditation, or beings from outer space. And they cling to whatever detour of half-truths or misconceptions they have chosen, blindly, without looking up to see if they're still headed where they want to go.

But how do you know when you're on the right road?

One way is to know the road yourself, to be sure of where you're going, to feel secure on familiar ground. That's not possible when you only go through life once.

It's equally reassuring to be on a road that someone else has traveled before, someone you can trust and believe.

That's the assurance Christians are offered. They know that there was one who went through life before them, who laughed and cried, worked and played, was loved and rejected. He not only went through life ahead of us, he went through death too, and wasn't destroyed by it.

So we can know that the road we follow does go somewhere. And that it goes somewhere we want to go.

But think of what it's like for an atheist. You can't depend on a guide; each person must find his or her own way. Signposts are meaningless because all journeys are relative.

You can't follow someone else's example – in a changing world that's different for everyone, anyone else's answers will mislead you. And there's no destination, because you eventually die, and that's all there is, my friend, there's nothing more,

No thanks, not for me. It's so much easier to follow someone who did it right the first time.

BIBLE READING

Jesus, the Way ~ *John 14:1–9*

Have a discussion with God, about the things that are different in your life from anyone else you know.
Then think about things that are the same for everyone
– that we all start with birth, all have friends, all face uncertainty, all end up in death.
Explore the idea that we are all novices, pioneers, feeling our way through our lives.
Say thank you to God for having become human, to show us how it can be done, so that we don't have to do our exploring alone.

Taking Time

● ● ● ● ● ● ●

As principal of the United Church's theological college in Vancouver for a quarter of a century, my father influenced a large number of students.

One of them, long after his college years, didn't praise my father's doctoral degrees, or his teaching skills, or efficient administration. He said, "If you went to see him, he always had time for you. He always seemed to give you his full attention."

I hadn't thought of it that way before.

When my father was first appointed college principal, he often worked until after midnight, boning up on the courses he taught. Later, when enrollments soared, the faculty doubled and a fully ecumenical school of theology grew possible, administration burdened his hours.

Yet I never once remember going to his office and being told he was too busy for me.

When I was a small boy and wanted help with hobbies, he gave it.

When I was a teenager, wondering how to respond to drinking at parties, he helped me untangle my thinking.

When I was a university student, pretending to be radical, he discussed my immature heresies as seriously as if they deserved it.

And when I became a novice editor, working for a church he knew much better than I did, he listened to

my insights with as much interest as if he had just dis-
covered them himself.

Was that his personality? Or was it an attitude he
worked at? I never asked him about it. But I think it's the
same attitude Jesus showed his disciples when he wasn't
too busy for little children.

When he took time for a blind beggar, or a sick man
lowered through a roof, or stayed up all night to talk with
Nicodemus, or risked his safety for his friend Lazarus.

Some people would consider such behavior poor stew-
ardship of time. It's inefficient – you don't get things done
when you take time for others. It's frustrating – you al-
ways fall short of goals you've set. And it may create hard-
ships for others – like Jairus, the ruler of the synagogue,
whose daughter lay dying, but who had to wait while
Jesus healed a woman in the crowd.

But on the other hand, what kind of a world would
this be, if Jesus (or my father, or any of us) stuck rigidly
to a timetable? What kind of world, if we brushed off
those children of all ages who need a little of our time,
sometimes?

If caring about others means inefficiency, I'd rather have
that than efficiency without caring.

... when he wasn't too busy for little children.

BIBLE READING

Risking all for a friend ~ *John 11:5–16*

*Confess to God, as a close confidant, some of the recent
times when you've been too busy to take time for people.
For your associates at work, your friends, your family.
When you have been with them, have you given them
your undivided attention for even 15 minutes?
Or has your mind wandered to your own concerns?
Have you resented their intrusion into "your" time?
Re-affirm that time belongs to God, not to you, and ask
for more sensitivity to the needs of others.*

The Legacy God Gave Me

I inherited wealth beyond many people's dreams. Now I have to figure out what to do with it.

It was given to me the moment I was born. The moment I took a breath, I inherited a country, a culture, and a tradition that I had no choice about.

I didn't choose my parents. Yet because of them, I was born Canadian. I inherited a country of blue lakes and green forests, abundant minerals, and soaring peaks. I inherited job opportunities and salaries, because my ancestors started industries and accumulated wealth. I inherited health from Pasteur, wisdom from Aristotle, and technology from Newton.

Because my mother taught English, I absorbed the value of words and the benefits of an international language.

Because my father taught Christianity, I grew up familiar with the love of a man called Jesus.

All that was my legacy. I had nothing to do with it. There were times, when I was a revolting teenager (in either sense of the adjective), when I wished I could be someone else and get rid of some of my inheritance. But I couldn't – and now I'm grateful.

My inheritance differs tremendously from those of, say, my friends in Malawi, in Central Africa. Their landlocked little country is cramped and crowded. They inherit no industries and no mineral resources. They inherit too little land for large-scale agricultural development, lan-

So my legacy really doesn't belong to me. I can't consider it mine to hoard. Or protect.

guage dialects limited to their own borders, and dependence on the nations that surround them for access to the markets of the rest of the world.

All that the people of Malawi can be sure of is poverty and death. Even their inheritance of life can be withdrawn at any time, by tropical diseases and a lack of medical care.

They didn't create themselves that way. Like me, they had no choice about their legacy. It was a given. By – you may call it what you want – an accident of birth, fate, heredity, or God's will. The name doesn't matter; the fact does. I didn't create, by my own efforts, the advantages I enjoy in my inheritance. They didn't cause their disadvantages.

So my legacy really doesn't belong to me. I can't consider it mine to hoard. Or protect.

Or bury, like the foolish servant who was so afraid someone would steal his one talent. I can't say to someone else, whose inheritance may be poorer than mine, "This is mine. You can't have any of it."

I don't know why I was given a rich legacy, while others received so little. I don't pretend to understand such things.

But it seems to me fairly clear that I am expected to do something with what has been entrusted to me. My inheritance is there for me to use.

One thing I know – I won't lose any of it by sharing it. It may even grow. For the more that health, and education, and compassion are available to everyone, the more of them there will be.

I also know this. The surest way to lose my inheritance forever is to try to keep it all for myself.

BIBLE READING

The widow's oil ~ *1 Kings 17:1–16*

Take a quick tour of all that you have been blessed with, from love you have received, to the things you like about the community you live in, to the world around you.
Now try to think of some people you know who don't recognize those same blessings around them.
Ask God to come with you, when you next see those people, and help you to create opportunities when you can lift their eyes and hearts, to recognize blessings, and their source.

Overflowing with Thanks

· · · · · · · · · · · · · · ·

"We have a word for sharing sorrow with someone – we call it 'sympathy.' But do you know of any word that means sharing someone else's gladness?"

It isn't easy to be thankful. Genuine "thanksgiving" is something we rarely feel in our lives. Usually we express thanks for getting, not giving. And even when something good does happen to us, there's a touch of envy, of spite, in our thanks.

"Is that all?" we wonder. "Why did he get more than I did?"

Or we shrug and say, "It's about time I got lucky."

We're even more stingy with our feelings when it comes to giving thanks for someone else's good fortune. Even as we congratulate the winner of a promotion, we're bitter that we were passed over.

A disgruntled minister said to me once, "We have a word for sharing sorrow with someone – we call it 'sympathy.' But do you know of any word that means sharing someone else's gladness? There isn't one! Maybe there isn't any such thing among humans!"

It took me many years to discover that there could be completely unselfish thanksgiving. While researching a story, I had been visiting David MacNaughton, in Nova Scotia. His young son, Scott, was in hospital for tests. The doctors suspected it might be rheumatic fever and they were afraid it could have damaged his heart. If it had, he would have to take special medication for the rest of his life and would always have to be careful of his health.

A few weeks later, to check on some details in my story, I phoned David's home. But before I could ask anything, Dave had good news to share. "Scott's okay!" he burst out. "It wasn't rheumatic fever after all! He's going to be just fine!"

And I seemed to fill up with a flood of thanksgiving. Not for me – but for them. I was almost in tears.

Perhaps as that minister said, there is no single word for such a feeling – but there are three. They come from the 23rd Psalm: "My cup overflows."

Suddenly, there is more than enough joy. When God gives so much that it pours over the cup and keeps on coming, you can't be selfish about it. The only thing you can do is share it. And that's thanksgiving – something worth celebrating.

BIBLE READING

The Lord our shepherd ~ *Psalm 23*

Try telling God about some people that you're happy for.
About the good times or happiness that seems to have
come to them.
About the way they are recovering from problems.
Now go a step further – assure God you'll continue to
be glad, for them, whether or not you share their good
fortune or growth.
Promise not to be envious.
Confirm God's faith in you.

"I Found It!"

● ● ● ● ● ● ● ●

One of the irritating questions that continues to divide the Christian churches is whether the Bible is literally true or not.

I can't get particularly worked up about it. Anyone who hasn't discovered for themselves how true the Bible is must have spent their life locked up in a deep freeze.

She searched everywhere for it. When she found it, she ran rejoicing to tell all her neighbors and friends.

Not as a legal document, mind you. To use a feeble analogy, the Bible is like a great play that remains great no matter what changes the director makes in the scenery.

Let me give you an example. Remember the story Jesus told of the woman who lost a silver coin? She searched everywhere for it. When she found it, she ran rejoicing to tell all her neighbors and friends.

I don't know whether that ever actually happened, or whether Jesus invented the story to make his point. But I know how true it is.

A few years ago, when Bruce McLeod was moderator of the United Church of Canada, he and I were traveling through South America. We were sitting in his hotel room in Rio de Janeiro one evening when suddenly one of my eyes went fuzzy.

I had lost a contact lens. I had no spare. I was panic stricken, afraid I would be half blind, unable to see well enough to do my job as a journalist for the remaining two weeks of our trip.

Bruce checked under my eyelid. He didn't find the lens.

We checked the armchair, my clothes, the insides of my shoes. No lens.

In despair, I returned to my own room. I picked up my magnifying shaving mirror for one more look at that eye.

And there, in a corner, tucked up under the lid where Bruce had been unable to see it, was the missing lens!

I remember running down the hotel's hall to hammer on Bruce's door.

Half-dressed, he flung it open.

"I found it! I found it!" I whooped. "I found…"

That's when Jesus' description of the joy in heaven over the saving of a sinner – like a woman who lost a silver coin and when she found it, ran to tell the neighbors to rejoice with her – popped into my mind.

"…I found my silver coin," I ended, getting everything mixed up.

But Bruce knew exactly what I meant.

BIBLE READING

The Lost Sheep, Lost Coin, and Lost Son ~ *Luke 15:1–24*

Tell God about times when you were lost, alone, didn't know where to turn.
Remember how, in different ways, people found you again, showed you they cared, helped you through the problems.
And how you learned that through it all, you could still believe in God.
Don't try to put your thanks into words – just let gratefulness flow out from you, at having been found, and at having found love.

Blood Sacrifice

· · · · · · · · ·

*Time or money
I can survive
without – but not
blood.*

I'm lying here, staring at the ceiling, while blood drips out of my arm.

And I'm trying to figure out why I enjoy doing this.

When I look at it objectively, giving blood to the Red Cross ought to offer little pleasure. How many people enjoy being stabbed in a sensitive fingertip to get a drop of blood for testing? Or having a big needle stuck into a vein? Or watching their blood run into a plastic bag?

And yet I have always found that after giving blood, my day is a little brighter. Giving blood makes me feel good.

I suspect it has something to do with my ideals. It's a way to share my abundance with someone else.

In one sense it's the ultimate gift. My blood, after all, is far more valuable to me than any gifts of time or money I can make. Time or money I can survive without – but not blood.

My pint of blood comes close to the traditional "tithe" – it's a fraction less than one-tenth of all the blood I have.

But unlike money, I get nothing back for giving it, except a glass of juice or a cup of coffee. No receipts. No income-tax refunds.

I know I'm giving it to someone who really needs my help. A beggar may use a phony sob-story to cheat me out of money. But the person on the operating table, the victim of a traffic accident, the leukemia patient, is in no position to cheat anyone or anything – except death.

I know too that my gift goes only to the person who needs it. Unlike money, none of it can be siphoned off by any intermediary for administrative or publicity expenses.

And it's completely anonymous. I don't even have to cope with embarrassing "Thank you's." Or the even more embarrassing lack of them.

I guess the biggest value for me is a kind of religious symbolism. At the last supper with the disciples, before being betrayed and nailed to the cross, Jesus said, "This is my blood which is shed for you." Church members hear these words each time they share the sacrament of the last supper, whether they call it communion, Eucharist, or Mass.

So as I lie here on my back, donating to the Red Cross, I can't help feeling that giving blood is like a sacrament. It makes his words a lot more real than sipping wine or grape juice.

BIBLE READING

The tithe ~ *Leviticus 27:30–34*
The Lord's Supper ~ *Matthew 26:26–30*

With God's gentle prompting, go over the kinds of gifts
that you have made to others recently.
How many of them would you give again next year,
and the year after that, if you didn't get anything back
in return?
And how many donations have you made without asking
for an income tax receipt?
How much of your time, as well as your wealth, do you
give away in God's name to others?
Ask God whether what you're doing is really good enough.
Assure God you'll watch and wait for an answer,
whether it comes right away or not.

The Unedited Bestseller

• • • • • • • • • • • • • •

I'm glad there were no editors around when the Bible was put together. If there were, it probably wouldn't be as valuable. It would be just another book.

As a magazine editor, I know that readers today expect certain qualities in what they read. They expect

- clear, concrete descriptions
- consistency
- a minimum of repetitions
- short, crisp speech quotes.

If someone were to submit parts of the Bible to me for possible publication, I'm afraid I'd want to edit much of it.

The Bible doesn't fit any of those criteria.

If someone were to submit parts of the Bible to me for possible publication, I'm afraid I'd want to edit much of it.

Aside from names and places, it doesn't have the kind of facts that mass media readers demand. For example, from reading the Bible, you would never know whether Absalom's long hair was blonde or dark, whether Noah ever hit his finger with a hammer, or if Mary was a good housekeeper.

The New Testament tells you neither the date of birth of its most important character, nor his age when he died on the cross.

Bits of the Bible keep contradicting each other. God created humans either first or last among living creatures, depending on which chapter of Genesis you read.

And the author of Acts can't make up his mind how Paul's conversion happened. In Chapter 9, the men traveling with him stayed standing and heard a voice speaking to him; but in Chapter 22, they didn't hear the voice; and in Chapter 26, they all fell to the ground.

If I were to publish inconsistencies like those in an article today, I'd be flooded with letters from readers gleefully pointing out my errors. I'd have to insist that the author do better research.

And the repetitions! Some stories appear four times, in each of the gospels. The Old Testament quotes God's instructions to the prophets, then repeats the whole thing when the prophet tells the people.

Any editor worth his wages could blue-pencil something on every page without losing a single incident from the whole story.

And yet this unedited Bible continues to be the best-selling book in the world. The scriptures are available in at least 1,500 languages. In 150 countries where the Bible Society operates, Bibles are in demand.

Why? I suspect because the Bible is about how God enters into the lives of very real people, people with all their faults and failures, joys and sorrows. In a sense, we don't read about long-ago people in the Bible – we read about ourselves.

Besides that, the standards demanded by modern journalism may make for easier reading, but as we're slowly learning, they don't always encourage understanding. For example, how much do you really know about political party leaders, even after all the well-publicized details of an election campaign? What counts is what people believe, deep down, and how they reveal that belief in what they say and do. The four gospels tell us that, about Jesus. So we can feel we know him – as well as we know members of our own families – even though we're never told how tall he was, or about his education, or what color his eyes were.

So I'm glad that no editors got their blue pencils into the Bible. The people who put together the various books and stories chose the pieces that mattered to them, that influenced their own faith and life.

And that's a lot more important, in the end, than sticking to any arbitrary set of journalistic standards.

BIBLE READING

Skim the interminable details of the Ark
of the Covenant
~ *Exodus 25:1 to 31:11, and 35:1 to 39:43*

*Ask God to help you sort out which parts of your life
might be remembered by the Christians who will live
after you.*
*Which parts of your life would you choose to be part of a
continuing Bible story?*
*Ask for God's help, day by day, in sorting out the things
that really matter, so that you can give them the at-
tention they deserve, and can avoid wasting time on
trivialities.*

4 · · · INSIGHTS FROM YESTERDAY

How the past illuminates the present

Once you admit that God may be revealing something to you in your ordinary experiences, you've got a problem. Which experiences?

All of them? That's possible, I suppose, though I doubt if God is going to say something profound to me each time I clip my toenails.

Then which experiences should you watch for? It's easy to miss their significance, if you aren't keeping your senses open for what God may be saying to you.

I find that I have to give attention to things that puzzle me, like why someone should develop cancer. Or things that upset me, like a quarrel with a fellow worker. Or things that scare me, like a close call with death. Then I file them away in the back of my mind, while I learn more about the Bible and the Christian faith.

I may have to wait years. But suddenly, someday, a word or phrase in a sermon, a parable that Jesus told, a bit of someone else's story, will burst into light in my mind. And I find myself thinking, "Aha! Now I understand!"

It's a feeling worth waiting for.

Missing a Miracle's Point

• • • • • • • • • • • • • • •

Heinz Guenther, professor of New Testament studies, says that we're missing the message when we focus on the supernatural or unexplainable parts of the gospels.

They take our minds off the real message. Not what Jesus was doing. But what happened to the disciples.

For example, we read the story of Jesus walking on the water (Matthew 14:22–33).

But our human experience says that it's not possible to walk on water. So you have to deny the truth of your own experience.

Or dispute the testimony of the Bible.

Or – a third possibility – you can grab at some more-or-less satisfactory explanations. Such as the theory that Jesus knew the lake so well, he knew where all the sandbars were. So he wasn't really walking on water, just wading through the surf. Unfortunately, such explanations fail to explain how a carpenter from a mountain village would know a lake better than local fishermen.

Dr. Guenther says that all these reactions are a waste of our physical and spiritual energy. They lead us astray.

They take our minds off the real message. Not what Jesus was doing. But what happened to the disciples.

When the weather got rough, they were in a boat. A boat is a nice, safe, familiar place for a bunch of fishermen.

Then they saw Jesus, on the water. How he got there isn't important. What matters is Peter's response. Peter had the courage to leave his safe, familiar boat, and leap out into the storm to be with his master.

Of course, he didn't have enough faith. At once, he began to sink. Like many who earn their living on the water, even today, he probably never learned to swim well. So he cried out, "Save me!"

Now, suggests Dr. Guenther, look at what the other disciples did. "Did they too leap over the side to save their endangered friend?" he asks. "No! They held a committee meeting, to decide who would succeed Peter as the rock on which the church would be built!"

The only help Peter got came from Jesus' outstretched hand.

That's the real message of the story, says Dr. Guenther. We too may find ourselves in the middle of a storm, when sin and injustice bluster around us. And like Peter, we too may be called to leap out of the safe, familiar life we know, into situations where we're in way over our heads.

But when we go over the side to follow our master, we shouldn't expect the others in our boat to follow us. When we find ourselves alone and sinking, we discover, like Peter, that our help comes from the Lord.

An Everyday God

BIBLE READING

Jesus walks on the water ~ *Matthew 14:22–33*

*Tell God about something you're expecting to happen,
something that bothers you.*
*Try to work out, in that conversation, where the problem
lies.*
Is it a lack of confidence in yourself?
A concern for what will happen to others?
*An uncertainty about what's really right or wrong in this
circumstance?*
Ask what God would do, in your situation.

Forgiveness Isn't Easy

· · · · · · · · · · · · ·

"Think of someone you haven't forgiven," came my minister's voice during a sermon.

That was easy. I knew someone who had caused me all kinds of problems for three years, and who had, I thought, brought disrespect to an entire organization.

"Now think of how you can go to that person and forgive him," the instructions continued.

And suddenly, I was stuck in a dilemma that seemed to have no solution. I couldn't go to that person and forgive him – not if forgiveness meant accepting his past attitudes and behavior. Not if it meant that he was going to go on harming those he worked with.

Certainly, it seemed wrong to hold a grudge against him, to try to stop him from working in that organization.

But it seemed much more wrong to let him continue.

There's always a terrible feeling that refusing to forgive someone is un-Christian. Jesus said there should be no limit to the number of times you forgive someone. "Not just seven times," he said, "but seventy times seven." He even asked forgiveness for the people who crucified him.

What should I do?

Two people helped me work the problem out.

One was a student minister. "Forgiveness doesn't mean washing your hands of a situation," she told me. "In the Bible, the rich man who forgave the debt his servant owed

him didn't get off easily. He lost that money. He took the servant's debt upon himself.

"Forgiving means taking the burden from the other person onto yourself, to help them."

She explained: "You'd like to be free of that burden. That's why you're finding it hard to forgive – why we all find forgiving hard to do."

She was right. I didn't want to commit myself to a continuing association with him. That was a burden I would rather forget, even without forgiving.

The second insight came from a pastor in Kenya. His words leaped out at me from a magazine I happened to pick up. In the Bible, he said, sin is not something one person does to another, but is the breaking of a relationship.

"Both the offender and the offended are equally guilty... If someone wrongs you, you have an obligation to rebuke him. If he repents, you have an obligation to forgive him..."

That was tough to hear. It told me that I carried a portion of the guilt – I shared in his "sin," because for too long I had failed to "rebuke" the other person. I had kept quiet, to avoid causing dissension.

But at the same time, it was a relief. The burden for forgiveness was not entirely mine. He too had a part to play. I can't forgive someone until that person is ready to be forgiven. I must wait.

> *"Both the offender and the offended are equally guilty... If someone wrongs you, you have an obligation to rebuke him. If he repents, you have an obligation to forgive him..."*

In that sense, the two of us are stuck with a continuing relationship, whether we like it or not.

No, forgiveness isn't easy. It doesn't get you off the hook at all.

No wonder most of the time when we say we forgive someone, the person probably hasn't done anything that really needs forgiving.

BIBLE READING

Instructions on forgiving
~ *Luke 17:3–4 and Luke 23:32–34*

Don't be timid – name the people, for God's hearing only, whom you have trouble forgiving. And say why.
Tell God which ones you have never told of your feeling they have done wrong, so that you have never given them an opportunity to repent.
Then commit yourself, before God, to forgive them as soon as it seems that they are indeed sorry. Are there any whom you can forgive now, because they weren't aware of what they were doing when they wronged you?
Do it.

Give a Little, Get a Little

A strange thing happens when North Americans travel to other parts of the world. Poverty manages to look attractive.

In Africa, I have almost envied the life of Zambian village boys. They don't attend school. Their responsibility is herding goats on arid hillsides. It's not particularly difficult, so they spend a lot of each day playing endless games of soccer in the sun, or they lie in the shade of a thorn tree and watch the diamond-bright day go by.

I've seen women of Haiti laughing and chattering in Creole, as they wash clothes on the bank of a little stream that bubbles down through the palms to the shore.

And I have stood in a misty glen in Ireland, where the sweet peat smoke eddies from a thatched cottage, and a weathered little man strolls up from the bay with a pair of fresh lobsters for supper.

Wherever you go in the less industrialized parts of the world, the people seem to have something that we have lost. They know how to take things easy. They don't have pressure to pay mortgages, or to get promotions, or to take part in a hectic round of volunteer activities.

Of course, we tend to forget that they may also have other things we don't have – things like intestinal parasites, or illiteracy, or malnutrition...

That's what poverty is.

The main thing they don't have is choice.

That's what poverty is. The main thing they don't have is choice.

Poverty isn't merely a lack of education, money, health, or a three-bedroom bungalow. We, who have all those things, can choose to live without them, to get back to nature. They can't. They don't have the choice. All the world's religions have a saying that goes something like the words of Job, in the Bible: "The Lord gave, and the Lord takes away." We often use such sayings as a consolation, when things go wrong.

"You win some, you lose some," we say.

But maybe we should treat it as a promise, an explanation of God's way of doing things. Not that you win one time and lose another time, but that each win is also a loss, that each gain involves giving something up. So when we go after something (such as money, knowledge, prestige, power) we stand to lose something else (like time, friendship, freedom from responsibility).

And every time we are prepared to give up something, we find that our loss is balanced by an utterly unexpected reward.

Freedom, but no water ~ *Numbers 20:1–11*

*Recall the times when things seemed to be going well for a
while, and then they turned sour.*
*Recall your feelings: were you grateful for the good times,
or bitter about the bad ones?*
If you are going through a bad time now, admit it to God.
Say that you're upset.
*Then promise to try harder to be grateful for the good
times, and to trust God to lead you on, to whatever comes.*

Charlie Chaplin Finished Twelfth

• • • • • • • • • • • • • • • • • • •

One of those indignant artistic types was talking on the radio the other night. I think he was a playwright, though he might have been a novelist, a poet, a painter, a sculptor, or even a musician.

"It's been proven over and over," he said bitterly, "that if you give the public a choice between the real thing and a plastic imitation, they'll choose the plastic imitation every time."

"Hogwash," I thought.

But then I remembered an incident involving Charlie Chaplin, back in the days when he was a star of the silent screen.

Everyone knew Charlie Chaplin. People stood in lines for hours to get into his films, even in the rain or snow.

And almost everyone did some kind of cute Charlie Chaplin impersonation – the funny strut, the short steps, the twirled umbrella...

It got to the point where country fairs had contests for impersonations of Charlie Chaplin.

As it happened, the real Chaplin was traveling in the eastern U.S. one day when he saw in front of him a poster advertising such a Chaplin impersonation competition. The prize was $100.

So he entered. When his turn came, he sauntered onto the stage with his black bowler hat, his baggy pants, the rolled umbrella, and the funny toothbrush mustache.

The judges concluded that 11 of the imitations were better than the real thing!

And that makes me wonder. Maybe the indignant artist was right. Maybe we do prefer plastic imitations.

If so, what about the brand (or brands) of Christianity practiced by Christians? For many, worship has become a peaceful interlude in the bustle of the week. Faith has become a comfort at times of stress – not unlike the soothers that mothers pop into infants' mouths when they get restive. Charity has become a handout. Hope has become a series of spiraling expectations.

But when I took back into history, I find martyrs whose faith impelled them into humiliation, poverty, rebellion, and even to their own funeral pyres. When Jesus worshipped God, he was always sent back out into society to love the unlovable.

Does Christianity no longer make such demands on its members? Or don't we recognize them when they are made? Have we chosen the plastic imitation instead of the real thing?

The judges concluded that 11 of the imitations were better than the real thing!

BIBLE READING

False prophets ~ *Matthew 7:15–23*

Talk with God about a few of the things that tend to lead people astray, their worship of power or money, or popularity...
Which ones are most dangerous because they particularly appeal to you?
Ask God for help and support in sifting the truth from the half-truth.

Triumph over the Torrent

The sun beat down on the mountainsides. Among the shaded roots of the evergreen forest, the winter's snow melted, seeping down through the soil, becoming trickles and streams.

It was the first hot day of spring. I was working on a forest survey in the wilderness behind Kitimat in northern British Columbia, tallying timber for a planned pulp mill.

Gordie Bradshaw and I had left camp that morning and waded across the cold, clear river to the other side. All through the day, as we worked, the snow peaks above shimmered in the heat; we heard the run-off tinkling musically to join the river below.

When we returned to the river ourselves, at evening, it had changed. The water that had barely reached our knees in the morning now raged down, roaring towards the canyon.

"Upstream!" Gordie bellowed in my ear. "The river's wider there. We might get across!"

Up to our waists in ice water, falling, holding each other up, we struggled across three channels of rapids. We stumbled onto the last gravel bar before the far shore. There was only one channel left.

It ran deep and black – too deep to wade, too swift to swim. And the water kept rising.

I recall mumbling, "One of us has to try it." Then I stepped in.

Gordie looked at a tree across the channel. "If someone would fell that tree, we could let the current swing us across on it," he dreamed.

Downstream, a long-dead tree trunk hung out into the current, which curled past it in an oily boil of angry water. "If we could get hold of that snag..." I suggested.

He looked at me. I looked at him.

We both looked downstream, to where our channel met the crashing chaos at the head of the canyon.

And we looked at our gravel bar, steadily shrinking as the flood kept rising.

I recall mumbling, "One of us has to try it." Then I stepped in.

The current, stronger than I had expected, whirled me away. The snag came hurtling towards me. For a ghastly second, I thought I would miss it. Then my fingers grabbed it, and I hung on as the water foamed over my head and sluiced through my jacket.

Somehow I wasn't torn loose.

Somehow, I dragged myself onto the log, and to shore.

Gordie hurled our axe across. I began chopping. Minutes later, he waded out to meet the falling tree, grabbed it, and hauled himself across. As he dripped onto the bank, he hugged me. "I thought you were a goner," he said simply.

An Everyday God

Yet if I hadn't tried the torrent, he would have.

There's an old saying: "Death makes cowards of us all." We learned that evening that it's not true. Only useless death does.

We didn't talk about it, out there on the gravel bar, but Gordie and I both knew the risks. And we knew the effort had to be made. So we did it.

All through history, other people have done as I did. In wars, in disasters, in sudden tragedies, people have discovered unexpected strength, refusing to be scared off their vision, their cause, their commitment, even by the fear of death.

If the prospect of death had made a coward out of Jesus, there would be no Christians today.

BIBLE READING

Laying down one's life ~ *John 15:11–17*

Let God ask you some questions, about your willingness to sacrifice yourself for others.
Perhaps about how much or how little you have really sacrificed.
What results did your sacrifice achieve in the other people's lives?
Then you try asking questions.
How must Jesus have felt, giving up his life to prove a point to people who barely realized what he was doing?
How did he feel, receiving capital punishment when he hadn't committed a crime?
Do you feel good when you make a sacrifice for someone else's benefit?

The Forgotten Father

• • • • • • • • • • • •

Joseph of Nazareth – remember him?

Poor Joseph always gets forgotten at Christmas. The attention focuses on the babe in the manger, the mother, the angels, the promise that this child would be the long-awaited Messiah. Everyone else gets the glory.

The woman he hadn't married yet was going to have a baby that he hadn't fathered.

Under the circumstances, who would blame him if he had walked out? The woman he hadn't married yet was going to have a baby that he hadn't fathered.

"If this Jesus is really the son of God," Joseph might well have said, "then let God have the responsibility for bringing him up!"

Of course, he didn't say that. And he didn't quit. We know he was still around when Jesus was 12, and lingered in the temple, listening to the priests and teachers. But that's the last time the New Testament bothers to mention Joseph.

Yet I suspect we know far more than that about Joseph. I have no doubt that Joseph was a good father to Jesus. Throughout the four gospels, Jesus refers to God as "Father" in a way that no previous Jewish prophet ever had, as a personal God, warm, loving, friendly, caring, forgiving, just, sometimes even with a sense of humor.

The word Jesus used, Abba, really translates better as "Daddy" than the more formal "Father." I have watched small boys diving off a dock into the Sea of Galilee. As they show off their fancy dives, they shout, "Abba! Abba!"

– "Daddy! Daddy! Look at me!"

That's the kind of closeness Jesus felt to God.

Surely if Joseph had been preoccupied with his business; or chased village women; or was harsh, cruel, or unjust – surely even Jesus would have retained traces of bitterness.

He would more likely have said that God was unlike human fathers. In fact, if Joseph had been a bad father, Jesus himself might have developed differently, might not have "grown in wisdom and stature, and in favor with God and humans."

Joseph gives the message of Christmas a different perspective. For every baby, in a sense, is a child of God.

And every parent may decide, for reasons that seem valid to him or her, to let someone else care for the child and to pursue instead that parent's own individual interests.

Bringing up a child of God is an awesome responsibility. But maybe opting out would be a more terrible responsibility. Remember Joseph. Think of how differently Jesus might have turned out, if Joseph hadn't done his best as a parent.

BIBLE READING

The birth of Jesus ~ *Matthew 1:18–25*

*Pick out a person who is, for you, the model of the kind
of person you would like to be.*
Maybe one of your parents.
Or anyone who has had a major influence on your life.
*Tell God about that person and why you admire
him or her.*
*Try to see, and explain, what characteristics that person
and God have in common.*

In the Family Way
• • • • • • • • • • •

At a science and theology symposium I once attended, Dr. David Roy of Montreal's Centre for Bio-Ethics talked about our understandings of right and wrong.

"Our system of ethics," he explained, "is based almost entirely on the family, or on a small community which corresponds to the extended family."

We don't often think of ethics that way. We tend to treat ethics as absolute principles, to be obeyed or broken.

But if you look at ethics in a family context, abstract concepts such as justice and equality take on a different perspective.

Many people think that justice equals punishment. For a murderer, hanging. For a rapist, castration. For a thief – well, how about the amputation of a hand or an arm, as prescribed under Islamic law in countries such as Saudi Arabia or Pakistan.

Similarly, many people think that equality means that Canadian tariffs should apply equally to all nations, rich and poor alike; that Canada's native people should not be coddled by governments, that women should compete for executive positions on the same basis as men.

But now try those concepts on a family setting and see how the picture changes.

Suppose you adopted a child, who had been under-privileged, perhaps ignored, or who was a war orphan. Wouldn't you give that child extra love and care, to make

up for what it had missed? Of course you would.

That's what developing countries, native peoples, and women's groups are asking for – extra consideration to make up for years of neglect.

Many people already use the family context to justify vengeance for serious crimes. They demand: How would you feel if your sister were murdered? Or raped? Or mugged?

But try it the other way around.

Suppose your sister committed the murder. Maybe her husband was drunk, and beating her black and blue. And she mashed his skull with the Mixmaster. Or she pushed him off the balcony. Or down the stairs. She murdered him anyway. Would you still insist on the death penalty?

Suppose your son were caught shoplifting. Would you still demand to have his hand cut off?

Or would you, with love and care and forgiveness, try to turn that son, that sister, around to a better life? That's the Christian way, Jesus said.

That's why he told the parable of the Prodigal Son.

In that story, the younger son came home after squandering his health and wealth.

The older son had some clear concepts of justice and equality – and they did not include special treatment like fancy clothes and fatted calves.

How would you feel if your sister were murdered? Or raped? Or mugged? But try it the other way around.

He wanted his younger brother treated no better than he was himself. And if he were to be completely honest, he probably really wanted this brother punished for what he had done.

But instead the father poured out extra love and affection for the one who needed it most at that time.

The father knew that in a family context, you don't treat people according to abstract concepts of justice and charity. You care about them.

Think about that, the next time your sense of ethics is outraged by something or someone. Would you feel the same way if someone you love were guilty? Is your rage really an admission that you care more about yourself than about them?

Prodigal Son, Part II ~ *Luke 15:25–32*

This may be difficult, but try telling God about the issues on which you are absolutely sure you're right.
Is it about the death penalty, or about abortion laws?
About marijuana, or alcohol? About immigrants, or pornography?
How comfortable do you find yourself, as you tell God what God's laws are?
Now ask for the humility to hear what God may have to say about those subjects.

The Everyday Miracle

● ● ● ● ● ● ● ● ● ● ● ●

Her opinion of herself was so low she didn't even dare to try to stop him to demand his personal attention.

You see it any time there's a celebrity around. People crowd around wanting to get her autograph, hoping to shake his hand, trying to borrow some reflected glory.

That's what it was like the day the Jewish official asked Jesus to come and heal his daughter. When Jesus began to follow the man, the crowds were so thick he found it hard to move through them. They were curiosity seekers, celebrity followers – all except for a woman who had been ill for years.

She was convinced that Jesus could heal her. But she was just a woman, growing old, weak, and useless. Her opinion of herself was so low she didn't even dare to try to stop him to demand his personal attention.

All she wanted to do was touch him. So she was working her way through the crowd to him, and she couldn't make it. There were too many people in front of her, crowds of publicity seekers who wanted to be able to say at their next party that they'd been so close to him they could have touched him.

And then Jesus was starting to move away through the crowd. With the last dregs of her energy, the woman got her elbows going, as if she were at a bargain counter. And reaching out as far as she could, as she fell forward, she touched the hem of his garment.

We who read and re-read that story in the Bible often think the miracle is that woman's healing, or that Jesus

felt her touch when there were so many others pushing around him.

I think there's another miracle that's even greater than the healing the woman later claimed.

As she fell, there would have been a moment's disturbance in the crowd. "Look out!" someone would have called. "What are you doing, you stupid woman?"

A few people might have tried to avoid stepping on her. They would have caused a small swirl in the flowing river of people, a little eddy that was soon gone. Then the crowd pressed on and flowed over and around her prostrate body.

But Jesus went back. He knew something had happened back there, and he wanted to know what. And when the woman realized that she was delaying not just one but two important people, she came to Jesus in fear and trembling.

But instead of being angry, he recognized her needs. Instead of being upset, he was kind. Instead of making her feel small, he made her feel valued.

That is the real miracle.

That's how Jesus treated people.

That's the miracle Jesus asks each of us to perform every day, as we too deal with people in the crowds around us.

BIBLE READING

The woman in the crowd ~ *Mark 5:21–34*

With God close to you and listening to you alone, name the people whom you have brushed off recently.
The ones you try to avoid, because you find them boring, or offensive, or unattractive.
Resolve with God's help, to try to treat them as if they deserved full attention just as much as you do.

The Garden of Eden

• • • • • • • • • • •

I remember the day I gave up my own Garden of Eden.

I had spent most of that summer working in the forests of coastal British Columbia. Spring had come to the mountain valleys, growing from an orange tint on alder twigs into the sun-bright emerald of bursting leaves.

Summer came, and the tangled undergrowth of wild blueberry bushes brought forth their purple drops of tart sweetness. Our tents looked out on frothing torrents and on lakes like crystal mirrors. And where I had once been a pallid city youth, I had grown tanned and healthy and confident of my ability.

On what turned out to be my last day in the bush, we started out in the pouring rain, following an imaginary line on a map up the side of a very real mountain.

As the drips off our canvas hats trickled down our backs, we paused to watch an otter frolic on a sandbar.

We waded thigh deep through an icy swamp while a doe and her fawn, unafraid, drank from its verges.

At the base of a cliff, we warmed ourselves at a campfire of wood abundantly waiting for us. Then we climbed the cliff, the nails of our boots scrabbling and scratching at the dark lichens coating the granite. Every time a foot slipped, the abyss below seemed to open up its arms...

But no one fell. Only the scars scraped on the rock by our boots, the pounding of our hearts, our breathlessness, testified to the number of close calls on that climb.

*Cresting the ridge
we gazed across
the broad valley
2,000 feet below,
speechless at the
majesty.*

Finally, as the leaden skies cleared, we broke free of the dripping forests into an alpine meadow. Like giants among warped and shrunken scrub cedars, we strode toward the vanishing clouds.

Cresting the ridge we gazed across the broad valley 2,000 feet below, speechless at the majesty.

Yet that evening, while our supper dishes washed themselves in a burbling pool two steps beyond the fire, a helicopter came for me. After six weeks without a hot bath, it was time for me to have a few days off in town.

I went.

The next morning, the project manager offered me an office job.

I took it.

Like people all over the world, from the beginning of time, I chose a warm bed, movies to see, a car to drive, and stores where I could buy the things I needed.

And like people all over the world, I look back with longing at those days in the idylls of Eden, when everything I needed was provided for me, could I but gather it.

Life has always been that way. Throughout history, people have chosen hot baths and comfort over the simple natural life. And they are still doing so, as underdeveloped countries opt for technology and industrial prog-

ress, in spite of the price they may have to pay in pollution and social disruption.

I suspect that's why the compilers of the Bible included the story of Adam and Eve in the Garden.

For when any of us taste of the tree of knowledge, we learn to make choices. We establish values, set priorities, and compare benefits.

God didn't send an angel with a flaming sword to keep me from returning to Eden. God didn't have to. I made my choice.

No matter how much I'd like to, I can't go back to Eden. None of us can. Ever.

BIBLE READING

Adam and Eve ~ *Genesis 3:1–7 and 22–24*

Share some of your deepest longings for places or times that you wish you could recapture.
Try to figure out what it is about them that appeals to you.
Now take God on a tour of your present life, and try to point out some areas where those same qualities still exist.
Ask for help in appreciating, and making the most of, your present life.

A Tale of Two Washbasins

● ● ● ● ● ● ● ● ● ● ● ● ● ●

He took that cheap washbasin and washed their feet as if he were a servant.

Two wash basins changed the world. One of them was probably silver. Or it might even have been gold.

We don't know what the other one looked like, though it probably was nothing more than cheap pottery.

All we really know is who used them – and that they really did change the world.

The cheap one was used to wash a dozen people's feet. Back in those days, travelers had no paved roads. They wore sandals. Their feet got dusty and dirty. When visitors came to a house for dinner, the host usually had a servant wash his guests' feet to make them feel more comfortable.

On the night of what we now call "The Last Supper," Jesus and his closest friends met for dinner. But there was no servant to wash anyone's feet.

Maybe the grit between their toes made them irritable – anyway, the friends were quarrelling among themselves about which one was more important. The only thing they agreed about was that, as followers of Jesus, they were far more important than ordinary people.

Then Jesus shattered their self-image.

He took that cheap washbasin and washed their feet as if he were a servant.

Peter, one of the friends, thought of Jesus as a king. "Oh no you don't," said Peter – or would have if he were talking today's language. "No way will you wash my feet!"

"That is how it has to be," Jesus told him, in effect. "Or you can count yourself out as my friend." And he explained: "You think of me as your leader. If I can do a servant's job for you, you can do the same for others when you become leaders."

Pilate, the Roman governor in Jerusalem, used the silver washbasin. He lived in luxury and power. He could free people or put people to death.

But when Jesus was tried before him, Pilate found he didn't have as much power as he thought. He couldn't find Jesus guilty of anything. Nor could he free him. Jesus, Pilate realized, was free to do things differently. But in spite of his authority, his Roman legions, Pilate had to do what people expected of him. So he sent Jesus to the cross.

But first, he took his basin, and washed his hands in it, to tell the world that he took no responsibility for what he was doing.

Jesus' washbasin showed that anyone can help people, and can care about them. If you're willing to serve, that is, instead of rule.

Many people still think the way to improve the world is to have power, like Pilate. Then they can force people to be good.

Fortunately, there are also people who are willing to try Jesus' way of changing the world.

BIBLE READINGS

Washing the feet ~ *John 13:2–15*
Washing his hands ~ *Matthew 27:20–26*

*Have there been times when you wished you had a little
more power, so that you could order others to do things
the way you want? Tell God about them.*
*Try asking God what Jesus' way of handling those times
would have been.*
*Would he have done something utterly unexpected,
dealing with truth rather than efficiency?*
Could you have done the same?
Tell God why, or why not.

First the Bad News

• • • • • • • • • •

We talk glibly about the gospels being "the good news." For us, who know about Easter, they are.

But for the participants in those gospels, there must have been far more bad news. Just try reading the gospels as if you were one of the people involved.

Think about Mary going to Bethlehem. She had married the carpenter, an important man in any village. She had status. Then she arrived in a strange town, where nobody cared about her, and nobody even knew her. She was suffering labor pains, unable to find a midwife or even a bed, giving birth to her first child in a stable. That would be like a high school principal's wife from Brandon, Manitoba, having her first baby in a parking lot at Portage and Main in Winnipeg. Humiliating...

Think about Jesus, after the Transfiguration. It was a moment when he seemed to be at one with God and with the history of the Hebrew people. Then he went down into the valley.

Instead of peace and harmony, he found his disciples squabbling among themselves because they couldn't heal someone who had convulsions, and drooled, and fell in the fire. Depressing...

It's like coming back home from an exhilarating retreat, loaded with discoveries about your faith – and the first thing you're told is that the washer broke down, the TV blew a circuit, the kids have chicken pox, and the roses have aphids.

Instead of peace and harmony, he found his disciples squabbling among themselves...

The biggest disappointment of all for everyone must have been the crucifixion. For Mary, seeing all her hopes for her oldest son nailed to a cross. For the disciples, seeing their leader, the Messiah on whom they had pinned their dreams, snuffed out as a common criminal. And for Jesus himself, knowing he was going to his death alone, abandoned by his closest friends, renounced even by the man he picked to be the foundation of his church. No wonder he cried out, "My God, my God, why have you forsaken me?"

Yet the good news did come out of all that disappointment. Nothing, neither life nor death, can extinguish God's love.

I try to remember that, at times when my life seems to be mainly dusty valleys and squabbling associates.

I try to remember that, when my ambitions and my years seem to be drying up in a wilderness.

I try to remember that I wasn't intended to spend my life in mountaintop experiences any more than Jesus and his disciples were. Our human ministries lie in the heat and grit of the valleys, in the tensions and tribulations, and sometimes the petty crucifixions of daily living.

Because the good news doesn't depend on mountaintop experiences. Rather, it sneaks through when we least expect it.

That's what Easter is – the unexpected good news.

BIBLE READING

The Transfiguration ~ *Mark 9:2–26*

Look back at some of the great moments in your life, and at what a come-down it was to settle again into everyday life.

Describe that frustration to God. Talk about your times of depression.

Then express gratitude to God that you are not alone in these times – that others have been through them too, and that God will be with you, to support and comfort you, through the valleys of shadow.

5 · · · CLUES FROM TODAY

When the past pops into focus

What part of the Bible puzzles you most? Is it Jesus walking on the water? Ezekiel's valley of dry bones? Jonah and the whale? Being told to love your neighbor? Noah's ark?

Whatever it is, you're not alone. I suspect that all of us have difficulties with something, somewhere in our faith. We don't like to admit it, though – perhaps because it seems as if we haven't told the truth when we repeated the familiar Creeds.

Yet a Creed is not just what I believe – it's what the whole community of faith through the ages has believed and – in general terms – still believes. It describes how millions of others have experienced God. Sometimes my experiences are not theirs – then I have doubts and questions.

But the Creeds, the Bible, and the church remind me not to let those doubts harden into disbelief. As long as I keep the questions open, it's still possible for God to provide a key to unlock the puzzle. Unexpectedly, something clicks – and it all comes clear.

I can now accept without hesitation many aspects of Christian faith that troubled me ten years ago. In the next ten years, I trust that new experiences and insights will enable many more pieces to fall into place.

Thy Kingdom Come

• • • • • • • • • • •

Can you imagine anyone deliberately turning down the kingdom of God when it's offered to them?

Many people do. Because they don't recognize it. They think it's something else.

They have good reason to be confused. For the Bible talks of the kingdom both as something that is to come, and something that is already here and now.

Something that's already here but hasn't arrived yet – that's a riddle that baffles most readers of the Bible.

When Jesus was explaining the kingdom to his disciples, he told them a series of parables, about how unexpectedly it would arrive: "Watch for it, for you can know neither the day nor the hour."

But talking to the Pharisees, who asked when the kingdom was going to come, he told them not to look for it in the future: "Behold, the kingdom of God is in the midst of you." (Other translations say, "within you," or "among you.")

Something that's already here but hasn't arrived yet – that's a riddle that baffles most readers of the Bible.

So people choose one or the other. And then they build their theology around that choice.

If the kingdom is already here, some say, things in this world are already the way they are supposed to be. So let's not change things.

If it isn't here yet, if the kingdom is still to come, say others, then the way that things are can't be the kingdom. So let's change everything!

John Macmurray, the British philosopher who died over half a century ago, wasn't satisfied with these approaches. When he read the gospels, he realized that Jesus always spoke in practical ways. Jesus didn't talk about systems (like capitalism or socialism), and he didn't talk about processes (like human dynamics or education), and he didn't talk about institutions (like churches or corporations).

Instead of building a worldview around a text, John Macmurray worked the other way. If Jesus was talking about practical human experience, then there should be something that was good, that we already had, but that could come without warning.

Macmurray found a very simple answer. Friendship.

We all know what it's like to have a friend, someone you can be easy with, who accepts you and whom you accept, with all your mutual faults and virtues...

Yet you can never predict friendship. Unexpectedly, an acquaintance, perhaps even a stranger, becomes a friend. And you may never know precisely when, or why, it happened.

But wouldn't that be an ideal kingdom? When everyone else was a friend? Or could be one?

Unfortunately, sometimes when friendship is offered, we turn it down. We'd rather nurse a grudge. Or it's somehow against our codes of social behavior. Or we're afraid of getting involved.

Maybe we're just too self-centered to realize that some-
one could be offering us the kingdom of Heaven.

BIBLE READINGS

The kingdom of Heaven
~ *Matthew 25:1–13 and Luke 17:20–21*

*Just wait a while, in God's presence, while you think
about people who may have offered you friendship.
Each time you think of an example, share it with God.
Think also of people who unexpectedly became friends.
Say thank you for them, and tell God why they matter
to you.
Ask if you have ever failed to recognize, and accept,
God's offer of friendship.*

Versions of Conversion

• • • • • • • • • • • • •

What does it mean to be converted, anyway?

There are those who insist that you can only be a Christian if you have been converted. They see conversion, most often, as a dramatic renunciation of your past life, a turning around from sin, an upsetting of your personal applecart.

I had that kind of experience once.

During high school days, a friend took me to an evangelical rally. I was deeply moved by the singing and the sermon – but I didn't go up for the altar call.

After the service, my friend introduced me to the evangelist, now out wandering among his well-wishers. He shook my hand briskly. "Mr. Smith here will take care of you," he said. Before I could protest, I found myself in a back room filled with people on their knees.

Mr. Smith prayed lengthily. Finally he stopped. "Would you care to pray now?" he asked.

It seemed to be the only way to get out of there.

Mr. Smith interrupted. "Have you ever thanked God for sending Jesus to die for our sins?"

1 gritted my teeth. "And God, thanks for sending Jesus..."

"Ahhh," sighed Mr. Smith.

"...to die for our sins..." Suddenly I could say no more. My eyes fogged. I choked back sobs.

"Amen," finished Mr. Smith on my behalf.

Was that a conversion experience? I say no. Looking back, I see no evidence that it changed my life.

But another experience did.

It wasn't dramatic.

But with the 20/20 vision of hindsight, I can see that it was a decisive turning point in my life.

I was leaving the Sunday school where I had taught for three years. Some 30 kids had gathered to say goodbye. The ten-year-old lad who had a fight every second week. The little girls who giggled constantly. The redhead who threw paper darts. The sweet blonde who always forgot her lines in the Christmas pageant…

Slowly, it dawned on me that I was going to miss them, that I loved them all. I had always thought of the command to "love your neighbor as yourself" as an impossibility. How could anyone care as much about others as about oneself?

Now that phrase stuck in my mind. I knew that I cared about myself, faults and all. And in the same way, I could love those kids, not just in spite of their faults, but sometimes because of them.

I realized with a sense of shock that part of the Bible I had been skeptical about had just been proven true to me, by my own experience. So what about other parts I was also having trouble with?

> *Looking back, I see no evidence that it changed my life. But another experience did.*

Maybe they were equally true? Could it be that I simply didn't want to believe them?

Suddenly, I had to look at my faith in a whole new way. It wasn't up to me to prove what was true or false. As long as I didn't close my mind, the answers to questions troubling me would come along. When I was ready to receive them. In God's good time.

And that realization did change my life. Not dramatically. But permanently.

BIBLE READING

The Great Commandment ~ *Matthew 22:34–39*

Tell God about the parts of your faith that you still are not sure of.
Don't be afraid.
As you talk about them, try to be aware of God's reaction.
Is it shock and rejection? Or acceptance?
Is God saying: "I know all about it, and it's all right"?
Let God ask you what difference it would make in your life if some of those doubts were cured.
Then agree to concentrate on the ones that would make a difference, and ignore the others.

Through a Glass, Brightly

● ● ● ● ● ● ● ● ● ● ● ● ● ● ●

What value is a poet? Not much, many people would reply.

Anyone can enjoy looking at a painting, or listening to music, or going to a show. So artists, musicians, and actors have some value.

But poets? They don't give you facts, like a newspaper story.

They waste paper; they don't fill each page with words, like a novel. They're not highly productive, sometimes laboring for days on a single phrase.

And above all, they're hard to read – they bend and twist words, forcing you to struggle with meanings and images and sounds...

A lot of the Bible turns out to be poetry – one reason why readers often get confused about what its writers were really trying to say.

What poets do is provide new lenses, for seeing hidden truths. And lenses cannot be rushed through or roughed out. They must be painstakingly shaped, finely polished, before you can see through them. The same thing applies to poetry.

Consider the situation in the Republic of South Korea, to see the value of a poet. People spend days accumulating facts and information about its political repression, or its economic progress. There are arguments for and against

speak, speak with
torn body,
every wound as an
open lip
as an open tongue.

its governments, its exploitation of garment workers, its jailing of church leaders.

But when you read the poetry of Kim Chi Ha, Korea's imprisoned poet, everything comes into focus, almost too sharply. Shells of partial truth get peeled away, leaving injustice exposed like a throbbing heart. Of torture and brutality, Kim wrote:

> speak, speak with torn body,
> every wound as an open lip
> as an open tongue.

Poet Kim never murdered, raped, robbed, or cheated anyone. But the lenses of his poems reveal too much truth; so former South Korean President Park Chung Hee shut him away for life. Kim spent years in solitary confinement, with a single bare bulb burning night and day in his cell.

Poets like Kim Chi Ha don't just tell us things that are true. Instead, they let us discover truth for ourselves.

That's why societies need poets. For a people without poets is a blind people, stumbling towards social suicide.

When did you last look at the world through the lens of a poem, in the Bible or anywhere else?

BIBLE READING

The poetry of David ~ *Psalm 18:4–19*

Tell God you're sorry that meanings have to be spelled out for you.
Ask God for a present – the kind of sight that can see things others miss, the kind of hearing that can hear what isn't said, the kind of touch that can detect the quiver of the heart.
Promise to use that gift to help others to see, and hear, and understand.

The Dog and the Prophet

● ● ● ● ● ● ● ● ● ● ● ● ● ●

I can still see his look of sorrow, of bewilderment, as we closed the front door and left him inside alone.

We once had a dog. He was just a mutt, a happy, yappy, brown and white terrier named Mickey.

We found him in the dog pound. Out of curiosity, one day, we visited the cages of dejected dogs. Something bright in Mickey's eyes, something in the way he cocked his ears and puckered his brow, attracted us. We paid our fee and took him home.

The first evening we had him, we had to go out.

I can still see his look of sorrow, of bewilderment, as we closed the front door and left him inside alone.

And we will never, ever, forget the welcome he gave us when we returned. He didn't merely wag his tail. He wagged everything. He vibrated himself into such ecstasy that his paws barely touched the floor.

Through all the years we had him, even when he grew older, he always greeted us with the same exuberance. The overflowing joy of his welcome helped heal the pain of temporary separation.

Mickey has gone now. But a while ago, he helped me understand the Old Testament. I had to look up Isaiah, chapter 54, in the Bible.

The prophet Isaiah used examples from the social customs of his time to make a point about separation. He was writing about the Hebrew exile and imprisonment in Babylon, a time when the people of Israel felt deserted by

their God. He talks of God as a husband, who has for a moment forsaken a young wife, cast her off, who has hidden his face in a moment of wrath. Then "with compassion" the husband takes the wife back again, and vows that his love shall never again leave her, "though the mountains may depart and the hills be removed."

At first, I didn't like what I seemed to be reading. I dislike macho males who think they have some kind of divine right to abandon their wives, have their fling, and then expect the wives to welcome them back gratefully. That's what it sounded like when I first read it. It may have been a meaningful description for God in Isaiah's time. But in my time I felt it an offensive analogy for God. I don't want to worship a fickle, self-indulgent, permanent adolescent!

But then I remembered Mickey. He never understood why we had to leave him alone sometimes – any more than we can understand why God seems absent from us in times of depression or turmoil, or when violence and injustice engulf the world.

I have no idea how deserted wives acted in Isaiah's time. But I know what Mickey did while we were away. He guarded our property. And he waited patiently for us.

Mickey showed me what to do when I can't perceive God around me, during those times someone called "the

dark night of the soul." I must continue to look after God's concerns. Be faithful. Believe that God still cares and will return. And whenever God is present, live in overflowing joy.

B I B L E R E A D I N G

God's love for Israel ~ *Isaiah 54:1–10*

You've had quite a bit of practice by now talking with God as someone right beside you.
This time, close your eyes, and imagine there is nobody there, after all.
Imagine you're all alone.
Then start talking to God again, as you have been.
Think how glad you are to have God to talk with, to be with.
Feeling joyful about God's presence?
That's a prayer in itself.

The Mouths of Babes

.

Ralph Milton doesn't expect to get theology from theologians. He has learned that some of the best theology comes from kids.

Ralph worked for the United Church in Alberta, as a broadcaster. A few years ago, on a radio series he was doing, he told of a conversation he had with his son Mark, about rainbows.

Scientists explain that light rays from the sun are caught by tiny spherical drops of water in the air, and broken into colors which make up the rainbow.

Theology professors explain the significance of the rainbow as a sign of the covenant made between God and humans, after Noah's flood.

But it took Mark to put those two together. He pointed out that we don't see as many rainbows as we used to, because pollution in the air interferes with the refraction of those light rays in those water droplets. Ralph remembers the shock of insight his son gave him – God continues to give us light and rain, but we humans have not lived up to our responsibilities in our Rainbow Covenant with God.

Another time, Ralph was writing an article on marriage. He and Bev, his wife, were discussing what had kept them together through bad times as well as good. Then they asked their daughter Kari, then 15, what she thought about it.

"When you know God loves you, it helps you love yourself," she said. "And when you can love yourself, you can love somebody else."

"When you know God loves you, it helps you love yourself," she said. "And when you can love yourself, you can love somebody else."

You could plow through volumes upon volumes of studies on the role of religion in marriage without finding a comment as penetrating as Kari's.

The only books I know that regularly speak as clearly and simply as that are the gospels. Jesus, it appears, shunned polysyllabic sesquipedalianisms.

Jesus, you see, knew God as someone real. He didn't need to build graven images of God out of words, as most of us adults have done.

That's right – idols of words. We shape an image of God as Omnipotent, for example, who can do anything. Or God as Creator, maker of heaven and earth. And then we think that because we have captured one aspect of God, we've got the real thing.

But kids haven't learned to kid themselves yet. Their thinking is still fluid enough that the clay of their ideas hasn't hardened into graven images.

And because they don't realize that adults are talking about their idols, not the whole God, kids say things that sound silly, but aren't.

Like the Sunday school pupil who listened to his teacher's explanation of omnipotence and creation, and then

asked: "Could God make a rock so big that even God couldn't move it?"

Was that a silly question? Or an intellectual razor that slices open some one-sided assumptions adults make about God, and reveals how silly they often are?

BIBLE READING

Jesus and the children ~ *Mark 10:13–16*

You might as well enjoy talking to God.
So tell God some of the funny things that children have
said to you – your own children, other people's children.
They don't have to be things about religion. Just fun.
Now let God interrupt and ask you how those things
they said reveal an uncluttered thinking – or perhaps
the muddled thinking that children have picked up from
adults.
Did they get some of it from you?
Ask God to work with you to straighten your
understanding, and to keep it open to fresh insights.

Frozen in Pillars of Salt

• • • • • • • • • • • • •

Faced with new challenges, new ways of life, a new world in front of her, she kept looking back. Poor old Lot's wife. Remember her? Lot was Abraham's nephew, and he was fleeing from the destruction of Sodom and Gomorrah. But Lot's wife – the Bible doesn't even dignify her with a name – looked back and was turned into a pillar of salt.

When I was younger, we joked about Lot's wife. Instead of asking for the salt at dinner, we would say, "Pass Lot's wife!" We chuckled at the absurdity of a person becoming a pillar of salt.

I don't laugh anymore. I see a lot of people around me turning into Lot's wife. No, I've never seen anyone actually turn into salt – but I know what happened to her. Faced with new challenges, new ways of life, a new world in front of her, she kept looking back.

She preferred things the way they used to be. She became petrified in the past.

It's a new world for all of us today. We can no longer gorge ourselves, blissfully ignorant of millions starving elsewhere. We can no longer pursue rampant industrial growth, complacent that what's good for GM and IBM is good for the world. We can no longer make snap decisions on social and economic issues, based only on limited experience and personal prejudice, when computers can sift through their vast information stores to process the information we need.

But I find many people would rather look back.

On the bus, I overhear, "Kids learned a lot more in school when they used the strap regularly..."

A fashion commentator states, "This spring, people are choosing the styles they remember from their own youth..."

Both business and labor condemn government intervention and demand a return to those good old days when a free market economy allowed them to work out their own problems, unimpeded by anything more serious than a Depression.

And a sure way to make a great many people clutch their past prejudices tightly around themselves is to mention words like sexuality, socialism, abortion, capital punishment, or immigrants.

Everything that's new isn't necessarily right. We can be led astray by trends and fads. And everything old isn't necessarily wrong. But to cling unthinkingly to past practices when God calls us forward into something new was wrong for Lot's wife, and is wrong for us today.

A phrase that has been called "The seven last words of the church" could just as well be applied to society as a whole. The phrase is "We never did it that way before!"

Like Lot's wife, it's a way of petrifying.

BIBLE READING

Lot's wife ~ *Genesis 19:12–26*

Let God call up for your thinking all the people whose ideas you rejected recently.
Maybe at work. Or at a church meeting.
Maybe you didn't actually reject them – you just told yourself their ideas wouldn't work.
Check them out with God.
Explain why you think the regular way of doing it is better.
Ask if God, being much older than you, is ever willing to consider your new ideas?

A Real Live Human Being

• • • • • • • • • • • • • •

Aside from being 45 minutes late, our flight out of Moncton, New Brunswick, was quite normal.

The sky was clear, the weather calm. None of the cabin attendants dropped anything or spilled anything. No one was drunk. Nobody got sick.

The flight was going so smoothly, so efficiently, it might have been the output of an idealized computer program.

Halfway to Montreal, our pilot spoke to us on the public address system. In a mellow, gently resonant voice, he apologized for being late. He explained what had happened, and told us when we could expect to land in Montreal. The words flowed so flawlessly, it could have been a tape recording.

Then he switched into French. Sort of. "Le duration de notre avion...uh...de notre avion..." He began fumbling for the right words – "uh...this evening...sera une heure et quarante minute. And we will be, oh damn, excusez moi, s'il vous plaît..."

Silence.

Then after a pause to get his French vocabulary together again, he was back. "Nous arriverons à Montreal about neuf heure et demi." And with a sigh of relief, audible before he managed to switch off his microphone, he went back to flying his airplane.

We suddenly realized we had a real live human being up there in the cockpit – not a machine.

We passengers grinned happily at each other. We suddenly realized we had a real live human being up there in the cockpit – not a machine.

It was a good feeling. And I suspect it was the same kind of feeling that Jesus gave people long ago in Palestine.

In those days, the laws of Moses had been refined and defined until they all meshed like clockwork. There was simply no room for any square pegs among the clicking cogs.

There were rules about what you could eat, whom you could work with, when you could draw water. One law specified the way you had to wash your hands: with the fist of one hand in the palm of the other, twice; letting the water run down your wrists the first time, off your fingertips the second.

Flocks of laws governed activities on the Sabbath.

Into this legal precision came Jesus and his band of unsophisticated Galilean fishermen.

They plucked grain and ate it on the Sabbath.

Jesus even healed people on the Sabbath.

And when he was challenged by those who strove to keep the machinery of the law ticking smoothly, he had the nerve to turn their tables on them.

Jesus pointed out that the great King David himself had broken their rules. And he cut through all the legalistic nit-picking about the letter of the law to reveal its spirit:

"Is it legal to do good on the Sabbath," he demanded, "or to do harm?"

"The Sabbath was made for humanity, not humanity for the Sabbath."

To the people of his day, he must have seemed like a breath of fresh air, someone who stripped away the impersonal efficiency of laws and regulations to reveal real live human beings.

I imagine his hearers, too, caught themselves smiling happily at each other.

"The Sabbath was made for humanity, not humanity for the Sabbath."

BIBLE READING

Doing good on the Sabbath ~ *Mark 2:23 – 3:6*

Celebrate a little – introduce God, in your thoughts, to some of the people who brighten up your life.
The eccentrics, who do things differently.
The spontaneous ones, who let their feelings pour out freely.
The unpredictable ones, who surprise you with unexpected kindness or insight or humor.
Be glad you know them.
Do you get the feeling God already knows your friends?
Welcome this added bond between you.

Why Joe's Parents Cried

· · · · · · · · · · · · · ·

There was a kid in my high school called Joe. He missed a lot of school because he kept having operations on his back for something. But he kept his grades up and somehow managed to be one of our best athletes, too.

I remember one school track meet. Joe came flying down the cinder track, those long wiry legs reaching for every inch of lead, and won the 100-yard dash. We all cheered for him.

Only a few parents ever came out to those school track meets. Most parents had to work on school days. But Joe's parents made a point of being there. They came down out of the bleachers to congratulate him. And to our surprise, they were crying.

Only one year later, Joe was dead. All those operations were for cancer of the spine.

That's why Joe's parents cried. Because they knew.

I wonder now what kind of courage they needed the day Joe told them he was trying out for the school football team. I wonder how they felt, watching his games, watching him swerve past one opponent, only to be smashed down by another's spine-jarring tackle. I can only guess.

Years later, another father told me about his son's inherited and incurable illness. "Most of the pain isn't giving up your child," he said. "It's giving up your expectations for him. You keep thinking what he could become. So

you try to protect him against everything, because of your hopes for his future. It's funny – until we accepted the fact that our son could die in spite of all our efforts, we couldn't let him live."

Jesus said puzzling things like that too. He talked about learning to live each day as if there were no tomorrow, about giving up your life so that you could have it.

It makes more sense when I think of Joe. He lived with his own death within him. His parents gave up their expectations for his life, and just let him live today.

One day, of course, there was no tomorrow. But Joe had a lot of good todays. And Joe had a lot of love.

The rest of us at that school used to feel sorry for Joe. "Poor Joe," we thought.

We should have learned something from Joe and his parents.

"... until we accepted the fact that our son could die in spite of all our efforts, we couldn't let him live."

BIBLE READING

The birds of the air ~ *Matthew 6:25–27*

*Ask God to forgive you for the number of times you have
tried to cross bridges before you came to them.
Listen as God reminds you about the number of times
things didn't turn out as badly as you had feared.
Say thank you, that God was willing to share the pain of
your experience with you.
And that God was willing to share the pain of being
human, in the person of Jesus.*

The Pain of Love

• • • • • • • • • •

A great hollow void inside me throbs numbly.

My friend's letter tells me that he and his wife are separating. He's leaving her their home, and their three children. One is a teenager already.

Perhaps "friend" isn't the right word. We don't see each other much these days. We haven't made a particular effort to keep in touch, to visit back and forth, or to drop in on weekends.

Yet I ache for him. And for them. I ache all over.

I remember how he used to wrap his arms around his oldest daughter, only 12 then, and how she curled up against him to watch the Saturday cartoons on TV. I remember, in the days when I worked more closely with him, how his wife's illness gnawed at his emotions, day after day. And when she recovered, I saw his world smile again.

I didn't know his wife as well. We weren't thrown together the same way. But I knew how much support he drew from her strengths when he felt lost and unsure of himself, or when the pressures of work overwhelmed him.

Perhaps he wasn't an easy man to love. He was a showman. He lived for an audience. He had an acid wit that could offend people. He could turn on – and turn off – his charm. And I knew from working beside him that even his brilliant and spontaneous ad-libs had been

Yet I ache for him. And for them. I ache all over.

169

mentally rehearsed, honed in his thoughts for just the right occasion.

Yet there was a genuine spontaneity to him that was irresistible. In spite of a penetrating intellect, a probing curiosity, a prestige education, he was never a stuffed shirt. In a room full of self-satisfied dignitaries, it was my friend who noticed the host's little son, lost and lonely among the academic gowns and sophisticated suits. And to the horror of those who honored protocol above humanity, he squatted on the floor to play pat-a-cake with the boy.

But more than anything else, he was driven by a vision. Beyond words, it told him what God's relationship with humans should be. It was like a hand in the middle of his back, pushing him.

I'm sure his dedication to that vision must have made him difficult to live with.

I didn't always share his vision. I didn't always defend his side, when he got himself into hot water. But I always supported what he is, and what he stands for.

In the past, I learned I could share his joys.

Now I find that sharing is not all joy. In their separation, there's pain.

And I find I can share some of that pain, too.

Is that what it means to love someone else as yourself? That their hurts, hurt you? As if your own heart were broken?

Maybe that's why so many of us have so much trouble following that deceptively simple commandment to love one another.

BIBLE READING

Jesus weeps for Lazarus ~ *John 11:17–35*

This may be difficult, but try to thank God for the pain you have suffered yourself, because it has helped you understand what others are going through.
Think of hurts that have healed now but can still come surging back sometimes – your mother's death, your spouse's illness, your child's revolt, your missed opportunities –
and thank God for them.
Try to share, in a small way, through your own experiences, God's anguish over the crucifixion.

Getting a Kick out of Life

If you're looking for thrills, you've got a world of choice.

At various times, I have enjoyed some things that people turn to for excitement. I know about the thrills of steaming down a long slope of deep powder snow on skis. And I have flown through narrow mountain passes in bush planes, when the wingtips barely lift past the treetops. And I have paddled a canoe down the surging, stinging roar of a white-water river.

But for sheer exhilaration, that magnificent sense of being simultaneously in control and over your head, I can think of little to compare with the motorcycle I owned, years ago.

Now, I drive a car – sedately, most of the time. But then...

...to wind the twist-grip throttle open, and hear the song of power build as the engine responds to my demands...

...to feel the wind tearing at my ears, tugging at my cheeks, as the speed builds up...

...to watch a long, winding road tighten into a ribbon of pavement, that dipped down into a cool valley, and lifted out, up and over the hills far away, a ribbon shaded by trees, bathed by sun, anointed by the flashing fragrances of wild flowers and summer grasses...

...and above all, to lean the bike hard into a sweeping curve – not going around scrabbling for traction like a

car, but with the tires biting into the asphalt, the foot-
rests kicking a shower of sparks off the pavement, with
centrifugal force always lurking, waiting for the moment
when you stretched your skills and machine too far, for
the moment when it could exact punishment for your
carelessness, and you never quite gave it the chance...

...that was motorcycling!

Of course, no one has to ride a motorcycle that way. It
can be boring just as canoeing, or horseback riding, or
perhaps even sky-diving can be.

And you don't have to do any of those things to get the
sense of sheer exhilaration that comes with committing
yourself in spite of the risk.

You can get it sitting behind a desk, in business. Or in
an operating room.

Or in a temple, perhaps? Because in a strange way, I
suspect that the man who cleared the moneychangers out
of the temple in Jerusalem would understand something
of what motorcycling or white-water canoeing is like.

Almost in slow motion, his anger must have grown,
as he saw how exploiters were defiling the holy place of
his people. And as it boiled over, as he laid his hand on
the first of the merchants' stalls, he would know he had
committed himself. Now there was no turning back, no
slowing down. He was in the chute, and he had to go
through to the end. And as the roar grew around him,

... to get the sense of sheer exhilaration that comes with committing yourself in spite of the risk.

... a zest for life,
his head back, his
hair flying, flinging
a shout of joy up to
the sky. as the tables tumbled, and the merchants scattered be-
fore him like squawking chickens down a highroad, I'm
sure he must have known the exhilaration of testing the
limits.

At times like that, I used to sing, laugh, shout. Do you
suppose he did too?

There's a drawing of him, that catches such a mood.
It's one of four by Canadian artist Willis Wheatley. They
show Jesus in various moods – sorrowing, thoughtful,
gentle...

But the one I like best is of the man who drove out
the merchants. Willis called it "Jesus Christ – Liberator."
Most people don't know it by that name, though. It's usu-
ally called "The Laughing Jesus," and it shows a man
filled with a zest for life, his head back, his hair flying,
flinging a shout of joy up to the sky.

And I get a kick, just seeing that kind of Jesus.

BIBLE READING

Clearing the Temple ~ *Matthew 21:12–17*

Tell God about the things you enjoy doing most.
Not what you think God wants to hear about, but what
you really enjoy.
What is it about these things that attracts you? Calm
and quiet? Excitement? Company? Tell God if you ever
invite Jesus along to do those things with you.
Why not?

Prayers on Black Friday

• • • • • • • • • • • • • •

How many times did Mary cry, "Oh God, let him die – but not this breath"?

A mother told me how her young son died. He had a rare and painful disease, an incurable deterioration of the entire nervous system. All they could do was wait. In the end, the nerves that ran his heart and lungs rotted. And the stillness of paralysis became the stillness of death.

It happened years ago. But she remembers sitting in his bedroom with only the night-light on, praying over and over: "Please, Lord, let him die – but not tonight, Lord, not tonight."

It must have been something like that for Jesus' mother as she stood below the cross watching her son die – only worse.

His was an agonizing death – and not just because of the nails through his wrists. A doctor told me once that death on the cross came from suffocation. With the body's weight hung from outstretched arms, after hours of exposure and pain, the victim's muscles weary. He has to make an effort to hold up his head and neck. When they slump forward, they cut off his breathing, and he strangles.

How many times did Jesus wrench his head up to gulp another breath? How many times did Mary cry, "Oh God, let him die – but not this breath"?

Perhaps it's only during such agonies that we learn how to refine our prayers. For the problem with fuzzy prayers is that the answers, if there are any, are equally fuzzy.

We too often pray in loose generalities. We ask for courage, or happiness, or mercy. We add "if it be your will" – making an answer both unnecessary and unrecognizable.

But when you are torn apart inside, prayers come into sharp focus.

I remember when cancer took my mother. At first, my prayers asked for some vague kind of healing.

She got worse. Each breath became a gasp. I held the bony hands that used to comfort me when I was small, and as her ribs squeezed down on the cancer growths filling her chest, I prayed for one more breath. Just one. One at a time was enough.

Until I eventually realized even that prayer was selfish. I was afraid of losing her. Then there was nothing left but to pray for her, instead of for me.

Jesus told those who were weary and heavy-laden that if they came to him, he could give them rest.

She was.

And he did.

BIBLE READING

The death of Jesus ~ *John 19:25–30*

Do you feel you know God well enough now to try asking some personal questions?

Sit, and sense what it was like for everyone involved to watch Christ die on the cross.

Then describe to God how you think you might have reacted, if you had been there at Calvary.

Tell God how it would have changed your life.

Resolve to make those changes now.

The Mechanical Waitress

• • • • • • • • • • • • •

She slotted back and forth behind the counter in the crowded New York coffee shop, zip, zip, like one of those wind-up toys that change direction every time they run into something.

She looked right at him spoke right to him and revealed a human being somewhere under the layers of workday habits.

She was as efficient as a machine – and with about as much personality.

Moments after you sat down, she clattered a cup of coffee in front of you.

A minute or two later, her progress along the counter would jerk to a stop in front of you. She neither said, "Hello," nor "Good morning." She didn't smile, or wish you a nice day. She didn't even look up. She grunted: "Yes?"

Her tone made it clear that you had better have made up your mind what you wanted.

Not even a nod of her head acknowledged that she had heard your order. She simply started up her engine and jerked away. Then sooner or later, something that more or less resembled what you ordered skidded onto the countertop in front of you.

Then, without warning, a customer, who was almost through his initial coffee, actually spoke to her.

"Miss?" he called as she trundled past. "You didn't take my order." As if he had pulled her plug, she stopped and the cup of coffee she was carrying slid off her tray and smashed on the floor.

It was almost as if she had shattered with her cup.

She looked right at him spoke right to him and revealed a human being somewhere under the layers of workday habits.

"I'm sorry sir," she said. "I thought I had asked you, and you said that just coffee was okay."

An even more remarkable transformation took place among the other customers. Suddenly, they lowered their newspapers, their invisible privacy fences. People looked at each other, exchanged a comment or two, passed the cream without having to be poked in the elbow.

So what's so important about a New York waitress? Only the way that disasters can shatter the walls we humans build between each other. Accidents and power failures, sudden illness or premature death cut through our pretensions and hostilities, and make us all equals for a while.

And often, it seems, the greater the disaster, the longer the effect lasts.

Look how people work together, former differences forgotten, when a flood or a hurricane strikes.

I think about that when I read the New Testament. It took a disaster to unite Jesus' disciples.

Before he was hung from the cross, his disciples bickered constantly among each other, arguing about who

would be the greatest, who would sit closest to the throne – and on and on.

... triumphs aren't the only things that unite people.

But after the Crucifixion, you don't read about them squabbling over such things anymore. Disagreements over policy, maybe. But not petty bickering.

Traditionally, we give all the credit for their change of life to the Resurrection, the events of Easter, and Pentecost.

But triumphs aren't the only things that unite people.

Black Friday may have had something to do with it, too.

BIBLE READING

Christ crucified ~ *Mark 15:21–39*

Run back through your life.
Pick out a few of the disasters that were rough then,
though you can laugh about them now.
What brought the survivors closer together?
After all these years, can you now admit to God that
they were worthwhile, even though you would never
want to go through them again?
Re-affirm your trust in God, yesterday, today, and
tomorrow.

Follow Tom

● ● ● ● ● ● ●

Poor old doubting Thomas. Of all the disciples and fol-
lowers of Jesus mentioned in the Bible, only his name and
Judas' have become part of common speech. They're both
seen as having betrayed their master – Judas directly, and
Thomas by doubting. By not having faith. By questioning
the Resurrection.

Thomas got a bad deal from history. Except for that one
incident, we would probably know him as "stout-hearted
Thomas," because the only other significant incident in-
volving him came when Jesus heard that his friend Laza-
rus was dying in Bethany, near Jerusalem, and decided
to return to that village.

The disciples just about went out of their minds. Jesus
had to flee from that area not long before to avoid being
stoned. When it became clear that he was going, it was
Thomas who said, "Let us go along with the master, so
that we can all die with him."

Unlike many people today, who use honest doubt as an
excuse for not trying ("I'd love to teach Sunday school,
but I'm just not sure enough of my own faith"), Thomas
stayed with the group of disciples. All he asked for was
the same evidence that Jesus had already offered the oth-
ers – the holes in his hands and his side.

They all had plenty of evidence for his death. They had
been there. With their own ears, they heard him cry out.

With their own eyes, they saw the spear lance up under his ribs. With their own hands, they carried his cold and stiffening body to the borrowed tomb.

They knew he was dead. Now Thomas wanted equally good evidence that he was risen.

They knew he was dead. Now Thomas wanted equally good evidence that he was risen.

Give Thomas some credit. He must have wished with all his heart that Jesus was not dead. Like most of us who, after the assassination of John Kennedy, kept hoping that somehow the whole thing had been a mistake, Thomas would have hoped that his master really was alive still. But Thomas was a realist. He wasn't going to give in to wishful thinking.

Significantly, Thomas didn't go looking for that evidence in the past. He didn't say he would believe if a gynecologist could verify the virgin birth or if a genealogical expert could prove that Jesus was directly descended from David. He asked for his evidence in the here and now.

I suspect that as long as we use history and archaeology to test the foundations of our faith – however valid those pursuits may be – we will only come up with more questions, and maybe more doubts. Like Thomas, we need to look for our evidence in the here and now. We need to learn how to recognize the presence of God in this world.

When I first started looking for that presence, I admit I didn't find too much.

Now that it has become more of a habit, I find so much evidence, in so many ways, that I wonder how I could have missed it before.

I don't have to have all the evidence. Just as Thomas didn't actually have to insert his hand into the wound in Jesus' side.

But as one example of God's continuing presence follows another, I find there's enough evidence – more than enough – to satisfy my doubts.

And like Thomas, I can say, "My Lord and my God."

BIBLE READING

Doubting Thomas ~ *John 20:19–29*

Try saying sorry for the times when you have failed to perceive the evidence God presents.
Explain why you still have doubts, and what they are.
Say what evidence you would need to satisfy those doubts.
Listen for a while to see if God agrees.

6 · · · TOWARDS AN EVERYDAY GOD

A new beginning

The prospect of recapturing the spirit of Pentecost, of discovering once more the presence of a living God as an everyday partner in our lives, terrifies some people.

I sat in on a study group on mission strategy one year.

Members of the group were discussing boycotting products from South Africa, or the Philippines, or Taiwan, as a protest against repression in those countries.

A slightly portly gentleman kept trying to haul the subject back to fundraising for missionaries and to support for development projects using Ottawa's dollars for foreign aid.

"But you can't pass your responsibility off onto others," a young woman protested. "We're part of what's going on in the world, whenever we buy goods from repressive regimes."

The point suddenly got through. "You mean," he spluttered, "that every time I buy a can of fruit in the supermarket, I've got to think about where it came from, and what that government may be doing? That's impossible! I'd go nuts! I can't afford to waste that kind of time!"

For many people, I suspect, an everyday God presents the same kind of problem. They think they'd go nuts, having God watching over their shoulder every time they did anything. They can't afford to waste the time to check

everything out with God, to treat each act as a moral decision, to reflect on the theology of their daily lives. It's easier to keep God sealed in a book or a building.

But God doesn't have to be a handicap.

No one would say that being in love was a handicap. When you're in love, you find that, somehow, your loved one is part of all you do. Even when he or she isn't physically present, you know that person cares about what you are doing and feeling.

So everything you do is done with that person in mind, and in a way that the loved one would approve of. Instead of being burdened, you get a lift.

It was that discovery of the presence of a living, everyday God that lifted and changed the disciples at Pentecost.

It can do the same for us.

Index of Seasons and Themes

Selections from *An Everyday God* that you may choose
for various occasions and topics.

S E A S O N S

Christmas	For the Good Years	41
	Looking for the Perfect Gift	67
	"I Found It!"	93
	The Pain of Love	169
Easter	The Testing of Fred's Faith	56
	First the Bad News	139
	The Mechanical Waitress	179
Pentecost	Getting a Kick out of Life	172
	Follow Tom	182
	A New Beginning	188
Thanksgiving	Overflowing with Thanks	90

T H E M E S

Communion	Communion Keeps Getting Better	32
	Blood Sacrifice	96
World day of prayer	Communion Keeps Getting Better	32
	The Universal Rock	44
	Walking Wealth that Jingle-jangles	78
	Blood Sacrifice	96
The Bible	Tuppence, My Arthritic Cat	63
	The Unedited Bestseller	99
	Missing a Miracle's Point	107
	The Forgotten Father	123
	A Tale of Two Washbasins	136
	Thy Kingdom Come	145
	Versions of Conversion	148

35	The Feeling Something's Wrong	*Faith expressions*
47	Too Much for Mere Mortals	
56	The Testing of Fred's Faith	
81	Following the Right Road	
130	The Everyday Miracle	
182	Follow Tom	
123	The Forgotten Father	*Family*
126	In the Family Way	
157	The Mouths of Babes	
166	Why Joe's Parents Cried	
169	The Pain of Love	
75	The Power of Positive Toothaches	*Forgiveness*
110	Forgiveness Isn't Easy	
75	The Power of Positive Toothaches	*Health*
110	Forgiveness Isn't Easy	
130	The Everyday Miracle	
157	The Mouths of Babes	
179	The Mechanical Waitress	
72	A Psalm for a Storm	*Joy*
90	Overflowing with Thanks	
93	"I Found It!"	
163	A Real Live Human Being	
172	Getting a Kick out of Life	
38	The Parable of the Pigs	*Life of faith*
50	God Doesn't Compete	
75	The Power of Positive Toothaches	
93	"I Found It!"	
116	Charlie Chaplin Finished Twelfth	
119	Triumph over the Torrent	
126	In the Family Way	
133	The Garden of Eden	
145	Thy Kingdom Come	
160	Frozen in Pillars of Salt	
163	A Real Live Human Being	

Mission	The Universal Rock	44
	The Testing of Fred's Faith	56
	Pass It On	69
	Walking Wealth that Jingle-jangles	78
	The Legacy God Gave Me	87
	Give a Little; Get a Little	113
	Through a Glass, Brightly	151
	A New Beginning	188
Prayer	The Testing of Fred's Faith	56
	The Power of Positive Toothaches	75
Small groups	The Parable of the Pigs	38
	God Doesn't Compete	50
	Taking Time	84
	The Pain of Love	169
Remembering	Songs of Hope	29
Stewardship	Walking Wealth that Jingle-jangles	78
	Taking Time	84
	The Legacy God Gave Me	87
	A Tale of Two Washbasins	136
	A New Beginning	188
Tragedy	For the Good Years	41
	Triumph over the Torrent	119
	Why Joe's Parents Cried	166
	Prayers on Black Friday	176
	The Mechanical Waitress	179
What God is like	God Doesn't Compete	50
	Work It Out Yourself!	53
	Tuppence, My Arthritic Cat	63
	A Psalm for a Storm	72
	Taking Time	84
	The Dog and the Prophet	154